D0336825

E.S.

PAINTING MINIATURES

For Bill

PAINTING MINIATURES

Elizabeth Davys Wood

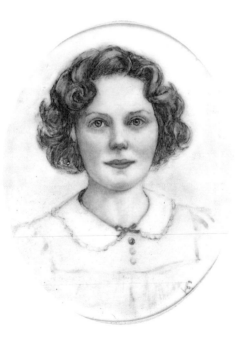

A & C Black · London

Acknowledgements
My grateful thanks are due to Judith Holden, Linda Lambert and
Anne Watts and especially my husband, Bill, for his help and patience.

First published 1989
by A&C Black (Publishers) Limited
35 Bedford Row, London WC1R 4JH

Published in the USA
by Watson-Guptill Publications
1515 Broadway, New York, N.Y. 10036

© 1989 Elizabeth Davys Wood

UK ISBN 0-7136-3133-3
US ISBN 0-8230-3717-7

All rights reserved. No part of this publication may be reproduced,
stored in a retrieval system, or transmitted in any form or by any means,
electronic, mechanical, photocopying, recording or otherwise, without
the prior permission in writing of the publishers.

A CIP catalogue record for this book is available from the British Library.

'Villa on Lake Como'
alkyds on ivorine

Typeset in Bembo (Lasercomp) by August Filmsetting, Haydock, St Helens,
and printed in Singapore by Singapore National Printers Ltd

CONTENTS

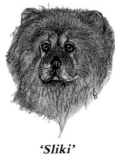

'Sliki'
watercolour on vellum

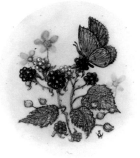

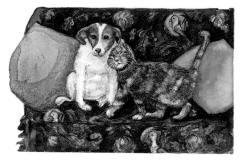

'Butterfly and Berries';
watercolour on ivorine; 5.5 cm diameter;
(circular frames available from 1 to 15 cm
diameter)

'Good Friends';
watercolour on designer's board; 8.5 × 6 cm;
(rectangular frames available 3 × 2 cm and
smaller, and up to 18 × 12.5 cm)

'The Savannah';
acrylic on card; 5.7 cm square; (square frames
available from 1 to 18 cm)

'Beauty' circa 1780;
watercolour on ivorine; 7 × 6 cm; (oval frames
available 2 × 1.5 cm and smaller, and up to
18 × 12.5 cm)

There is a wide choice between the smallest and the largest. Comfortable sizes to view – and to
paint and hold – are as follows: circular 6 cm diameter; rectangular 7 × 5 cm; square 6 × 6 cm and
oval 8 × 6.5 cm.

A size well within 18 × 12.5 cm will prevent the miniature from being labelled a small picture.

INTRODUCTION

The contemporary miniature

A miniature painting is a picture no larger than 17.5 × 12.5 cm; yet it can be as small as the artist can paint and the viewer can see! Visualize a medium-sized envelope and a postage stamp – these are the sort of parameters you can choose to work within.

Miniature paintings often have a special, intimate quality about them – some may be worn as pendants, others hung in groups to make an intriguing corner of the sitting room. They can be painted in many shapes – ovals and circles as well as rectangles and squares. A pleasing size for an oval is 6 × 8 cm; 5 × 8 cm is good for rectangles, and a diameter of anywhere between 3 and 10 cm is advisable for the circular miniature.

Subject matter is unlimited. Earlier miniaturists put their skills mainly into portraiture, though this was emphasized less when photographs became accessible to the public. Today, every subject, landscape, flowers, small fruits and berries, birds, wildlife and so on becomes an enchanting possibility for the miniaturist.

Miniatures can be painted in most mediums – watercolour, gouache, oils, alkyds, acrylics and even mixed media. There will, however, usually be some controversy over whether or not a pencil or line-and-wash drawing drawn and framed to the size of a miniature can legitimately be called one.

Styles and approaches to miniature painting are changing a certain amount, but miniatures are still usually exemplified by finely detailed painting and emphasis is placed on the traditional techniques of the old masters. So, if you are simply experimenting for yourself, and want to paint miniatures with a loose wet-in-wet watercolour style, or use a small palette knife for oil miniatures, go ahead, and don't be constrained. The main thing is to become accustomed to miniaturizing any subject within reason. Suggestions and ideas follow to help you begin.

The search for a subject

Begin to 'think miniature'. It is quite common to draw forms smaller than actual size. Don't feel restricted in your choice of subject. All sorts of subjects lend them-

selves to close attention – people, animals, still life objects, ships, old buildings, famous figures of the past etc.

Keep a small pocket-sized sketchbook and a pencil or few crayons to hand. A few strokes quickly penned can act as an invaluable reminder once you begin to draft your miniature. Keep colour notes in your sketchbook and indicate specific areas that might provide the main theme for your painting.

Invest in some good photographic reference books and keep old magazines and catalogues. They can be invaluable for the detail of the bird that flew away or the flower seen last summer or for getting the military uniform of an old character just right. Browsing through them may also trigger off some new ideas for paintings.

Still life subjects are easily found in objects around the house. You might find a pretty design on an old china cup which sparks off an idea. Flowers can easily be picked or purchased and followed up by looking at gardening books and catalogues. Sketching flowers can often be done once the light has failed and then linked with notes in your sketchbook.

Your previous paintings on a larger scale may lend themselves to being scaled down to miniature size. (I talk about how to do this on p. 57.) Photographs that you have taken may also be a good inspiration for pictures.

Give careful thought to your first miniature. Just because a miniature is small does not mean it can be painted quickly – each is an adventure to be enjoyed and not to be hurried over. Errors in drawing, lack of understanding of tonal values and so on can easily spoil a miniature. You will need to be disciplined to master the basic techniques.

I hope you will start with some of the basic exercises suggested in chapter 2. These will help you to handle the different surfaces and smaller brushes. Remember – keep the subject simple to start with. First capture your idea – sketch it out – plan your composition, and then comes the joy of applying colour!

1
SURFACES AND MATERIALS

A wide range of surfaces is available for painting miniatures; almost any surface used for a larger painting can be cut down or shaped for use by the miniaturist. Some surfaces, however, may not be as suitable for the medium you wish to use, so choose thoughtfully. If you are already familiar with a surface, see how you can adapt it. For instance, as a watercolourist, you will certainly have used paper in varying qualities and weights – now you must find one that is smooth and discard the heavier ones which would prevent fine brushstrokes. If you are familiar with oils and have used canvas or canvas board, you will find that any coarseness of weave can't be disguised by fine brushwork. You need not confine yourself to expensive surfaces. If funds are limited you can be ingenious and find alternatives.

Surfaces used for the watercolour miniature

Paper
Heavy cartridge, hot press and designer's board are all papers which have smooth surfaces. Their great disadvantage compared with ivory and ivorine is that mistakes in drawing and painting can't be washed off, and this can lead to loss of clarity in colour if you find yourself overpainting to correct mistakes.

Vellum
Vellum was traditionally used by the early miniaturists; it is one of the more expensive surfaces. It is sometimes available from well-stocked art shops although you may have to order it specially.

Don't confuse it with the vellum used for making lampshades. The miniaturist requires vellum which has been specially surfaced to avoid any slight imperfections, as watercolour will quickly settle into any small cracks and mar the work. Vellum is not as sympathetic for the beginner as errors cannot be continually washed off as on ivory or ivorine. It will, however, stand up to some alterations in the early stages of a painting. It was used by all the earliest miniaturists.

Ivory

Ivory replaced vellum to a large extent during the 18th century. (Historians often date miniatures by the fact that early ones were done on vellum and later ones on ivory.) Ivory became a favourite with the old masters because its semi-transparent quality is ideal for the portrait miniature. Also errors can be easily washed off ivory though it won't stand up to the endless alterations that ivorine will. Eventually it will begin to develop very tiny cracks into which colours will settle. This is called 'worrying'.

Ivory needs careful cutting with fine scissors. It has both a wrong and a right side which is easy to see when you hold it up to the light. The fine saw marks from slicing can be clearly seen on the wrong side. These saw marks have to be erased on the correct side leaving it properly 'prepared'. Ivory can be, and usually is, purchased ready prepared, from special shops and agencies. It is called leaf ivory. The sizes you buy will depend on availability but a useful guideline is to look for ivory leaves cut to 7.5 × 7.5 cm. Note – small pieces are sometimes available and these are ideal for locket paintings. Ivory is more expensive than ivorine.

Ivorine

Ivorine is a man-made imitation ivory which has a white translucent appearance. It is the perfect surface for the miniaturist as it allows the artist to build up colour and to wash away errors.

'The Dog Next Door'
watercolour on ivorine

Surfaces used for the oil miniature

Canvas

I do find that the canvas used for larger paintings is too coarse for the miniature, but

a fine linen handkerchief glued to a card and then sized with two coats of acrylic gesso primer will make an ideal base for the oil miniature. Be sure to make the linen dimensions adequate to fold over the edge of the card to prevent fraying.

Oil paper

Choose oil paper without an imitation weave or grain, and keep your miniature on the small side if using this surface. It may buckle unless stuck to a good firm backing.

Wood and hardboard

Both wood and hardboard make good surfaces. Be sure you cut the material carefully to the dimensions needed for your intended frame before painting – you don't want to scratch the finished work with a saw! The surface should be well sandpapered and very smooth. Add several coats of gesso primer, rubbing down between each coat. Bear in mind the thickness of the surface, and that ovals and circles will be rather difficult to cut.

Ivory

As ivory is a costly surface it seems a pity to use oils on it they have such a depth of colour that they can easily disguise the precious base and anyone looking at the picture could be quite unaware that ivory was used. However, the choice is up to you.

Ivorine

Ivorine makes an excellent surface for oils as still wet work can be wiped clean away if you are having problems. Ivorine is also durable enough to allow for a rich build-up of colours.

Vellum

Oil takes readily on vellum, which is easy to cut to shape and size.

Copper

Copper is not often used, but oil paint can take on a particular luminosity when painted on this surface and some unusual effects can be created by carefully removing some of the paint and allowing the copper to shine through.

Formica and other laminated plastic surfaces

Off-cuts of these materials are available from builders' merchants. It's best to choose white pieces and have the materials cut to size with a saw before you begin painting.

Surfaces used for acrylics, alkyds and gouache

Both acrylics and alkyds have similar properties to oils and are widely used by contemporary miniaturists. Artists used to painting in oils will find both these mediums ideal as they are quick drying yet capable of considerable depth of colour. Errors can be painted over. Ivorine and hardboard are ideal surfaces for these mediums. Gouache, too, is popular, and looks well both on paper and ivorine.

Materials

Always invest in the best materials you can afford.

Brushes

Brushes will last years if you take care of them. You will need to buy brushes specially made for the miniaturist, which have a sable tip and come in seven sizes. The smallest is the treble 0 (i.e. 000) and the largest is size 4. All come to a sharp point when wet. Sizes 3 and 4 are used to lay in the first washes, and all the others are used to paint the detail. The finer the brush the shorter its working life, and brushes tend to get gradually down-graded as they become worn and lose a few hairs.

It is a mistake to think you can paint successfully with brushes of a similar size but with longer hair. The miniature brush is constructed to hold a good quantity of paint yet fine enough to enable you to 'draw' in colour. Always wash well after use, and stand brushes tip uppermost in a small pot. Sable brushes can benefit from an occasional good wash with hair shampoo.

Pencils

Always keep a good supply well sharpened and standing point uppermost in a container. Acquire several pencil sharpeners, or use a knife or razor blade.

Erasers

The 'putty' sort of erasers are best as these can be rolled into small sausage-like shapes for erasing a tiny part of a pencil drawing.

Dividers

A pair of dividers is invaluable for comparing proportions, especially in portraiture. Both simple and proportional dividers are available. The proportional dividers are highly calibrated, need careful adjustment and are very expensive, but they are also very useful for scaling up and down. For the beginner, simple dividers would be

much easier to use and much cheaper to buy.

Magnifying glass
This is an important piece of equipment. You really need two. One that will fit into the pocket and can be used when studying miniatures in museums, and a larger one for use in your working area. The latter has a long flexible arm allowing for correct adjustment over the work. Some versions have a light surrounding the glass for use when working in artificial light. (This is standard drawing office equipment.)

Drawing pins
Choose drawing pins with a long shaft and sharp point.

Blotting paper
Buy white blotting paper only, and use it to rest your hand on when painting.

Tracing paper
Keep a supply of tracing paper by you. Corrections can be drawn on tracing paper and placed over the original work.

Clean rags
Fine cotton rags are best, white if possible.

Water jar
A glass jam jar will do; because you are painting miniatures doesn't mean you need a tiny container.

Ruler and set square
Both of these are good aids to scaling up and down.

Gum arabic
Gum arabic was used by some early miniaturists to gain depth of colour quickly when using watercolour, but it should only be used with great caution. It leaves a shine, is slow drying and may eventually leave a mould or fungus on the painting. Its long term effect on a man-made surface like ivorine is also doubtful. But it does have its uses when mixed with gold powder and applied on paper, particularly for silhouettes, where a shine can look attractive.

Ox gall
A supply of ox gall isn't vital, but if you can get hold of it, it's useful for cleaning grease from surfaces.

Turpentine and other mediums
Turps can be used for thinning down oil colours. Other mediums with various properties can be used with acrylics and alkyds, and their effects are discussed on p. 40.

Gesso
Different types of gesso are available, and I would recommend the acrylic material, which can be purchased from any good artists' suppliers. It dries quickly when painted on wooden panels, hardboard and cardboard.

Flour paper
Flour paper is the finest sand paper available; it is useful for rubbing down hardboard, wood, ivorine and ivory to give key to the surface before you start to paint.

Folders
A miniature is vulnerable until securely framed, so it's worth making an individual 'folder' out of paper or some other material to keep the painting safe while work is in progress.

Attach your miniature to the inside of a small paper folder to keep it free from dust.

Scrapbook
Keep all your working drawings, date them and give them a title. Keep a record, too, of any miniatures you exhibit or part with – you'll find it useful to look back on.

Drawing board
A sturdy drawing board may be useful to you, for working drawings can be pinned to the side of the miniature, yet leave ample space for the painting itself.

Cardboard cut-outs used as 'viewfinders'

I make constant reference to these throughout this book – they are very useful when deciding on composition and sorting out what area of a larger subject to concentrate on.

General comments

Your working space is important but you don't need a studio to paint miniatures, just a well-lit corner. You need a steady table, a comfortable chair and, in cold weather, good heating. In hot weather, you will find it difficult to work in the open air, so sit near an open door or window.

Plan your working time carefully, and take frequent breaks. It helps to wear a comfortable cotton or silk shirt rather than anything which is fluffy or likely to shed hairs on the painting surface.

Miniature painting will not harm the eyes, but it is worth having a regular check-up with an optician, taking along a miniature to show the kind of work you're doing. However, painting once the daylight has faded really isn't advisable unless you have a strong light bulb fitted and placed close to your work. It's not a good idea, either, to begin when you are tired; this is the time to do some sketching in pencil and gather your ideas together.

Dust is the bane of miniaturists, as minute particles will settle onto a freshly painted surface before it has dried. You could put watercolours or miniatures painted in other fast-drying mediums in a folder, or cover work with a plastic film; and do try to keep your working area as free from dust as possible.

If you are working in watercolour on ivory or ivorine you can get rid of dust which has settled onto the work by polishing it with a piece of silk; this slight polishing also hardens the surface, and makes it less likely to pick up further particles of dust.

Wax polish

A micro-crystalline wax (brand name 'Renaissance') is used by museums and restoration specialists to revive and protect paintings and, used sparingly on the surfaces of ivory and ivorine and polished with silk, will give a soft sheen to a miniature.

Finally a good quality wooden writing box with a lid, which opens and has a sloping side (you can find these in antique shops or even make one yourself) will be a splendid hold-all for your materials. The sloping side can act as a work surface.

Frames and framing

Some early miniaturists were also goldsmiths and made beautiful jewelled frames which were an integral part of the design of the miniature. The frame still plays a vital role in the presentation of the finished miniature; it can be made of wood, gilt, brass or silver. In many ways it is easier to choose and fit the frame to the miniature at the very beginning of a painting, as this will not only dictate the scale and help the composition but also it can be placed over the work while it is progressing. This, for me, always acts as a spur towards the finished work. However, to begin with you could use a cardboard or paper cut-out, with an aperture cut to the shape of an oval, circle, square or rectangle (the latter can be used either vertically or horizontally); this is a very helpful guide. For sketching purposes, lay frames of masking tape on sketch paper, cutting and fitting the tape to a variety of sizes and shapes. Keep these sheets readily available in your workbox.

The colour of the frame and its border can be taken into account when planning the work; for example, a silver-haired lady dressed in a pretty pink dress may have the highlights in her hair reflected in the shine of a silvery frame. Portraits often look well with a gilt or silver edge close to the work – landscapes and flowers also look well in gilt but of course ordinary wooden frames are perfectly good and can be constructed easily to small sizes. There are many delightful woods which make beautiful miniature frames. Do be careful not to cheapen a work by an over-ornate frame. A painting should only be enhanced and protected by its frame.

Note – Miniatures, even those done in oils, seem to need the protection of being covered by glass.

Care of the miniature

Given a reasonable amount of care, a miniature should last indefinitely. It should be properly backed and framed and not exposed to strong sunlight. Avoid hanging them over fireplaces or central heating radiators.

Ivory suffers from any extreme changes of temperature and is the only surface which may change very slightly with age; if care isn't properly taken the ivory may darken, and violent changes of temperature may cause it to crack. Avoid dust, damp and direct sunlight, and you should be able to preserve your miniatures very happily.

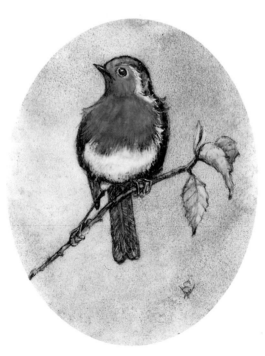

'Robin'
watercolour on ivorine

2 COLOUR AND METHOD: WATERCOLOUR AND OILS

I tend to paint primarily in watercolour so quite a lot of my examples and demonstrations throughout the book are in this medium. But I also explore the use of oils, acrylics and alkyds, and, as mentioned before, you can adapt whatever medium you happen to be familiar with for the miniature. To get you started, I will look at each medium, begin by suggesting a palette (by which I mean a range of colours) and then enlarge on my own working methods in a number of demonstrations. Some demonstrations are particularly designed to help you learn by following them through stage by stage yourself and modelling your own painting on what I show you. Other demonstrations, in the later part of the book, will be more difficult to reproduce yourself, but again I have broken down my own working methods into stages as this is a good way of analysing a painting as it emerges.

Here is a general summary of my method of working, which will apply with all mediums. There are seven main stages through which you will progress:

1. Drafting the idea and establishing the composition.
2. Transferring this drawing onto the chosen surface by outlining the main shapes.
3. Blocking in these simplified shapes in thin colour.
4. Deepening the colour where necessary.
5. Enhancing the drawing by more work with a fine brush.
6. Strengthening the work with fine detail.
7. Framing.

Choose a limited range of colours to start with and work from these until you thoroughly understand just what you can do with them. A wide selection of colours is confusing initially, though you will welcome additions to the paintbox as you become more experienced. Always buy the best quality paints you can afford. 'Artist's' colours in both watercolour and oils will last for years.

Watercolour

The palette I recommend initially is:
cobalt blue, cerulean blue, light red, rose madder, lemon yellow, Paynes grey, raw umber, yellow ochre, vermilion, cadmium orange.

Further additions could be:
aureolin, raw sienna, viridian, Prussian blue, French ultramarine

White saucer for mixing colours

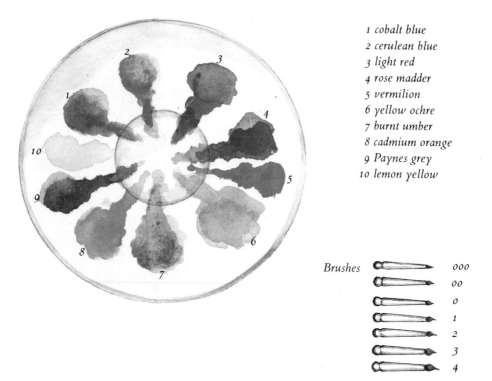

1 *cobalt blue*
2 *cerulean blue*
3 *light red*
4 *rose madder*
5 *vermilion*
6 *yellow ochre*
7 *burnt umber*
8 *cadmium orange*
9 *Paynes grey*
10 *lemon yellow*

Brushes

000
00
0
1
2
3
4

Note that I don't include black or white, but the watercolourist will also find a small tube of designer's gouache in white very useful, just for highlighting the edge of lace, an animal's whiskers, the highlight in the eye, and so on. It needs to be applied delicately.

There are many books published about the watercolour method, and it will be helpful to look at these. You will be using smaller brushes, working in fine detail, and, obviously, working on smaller surfaces, so begin by playing about with colour mixing, and getting used to smaller brushes. Initially you can do this on paper; later you will need to become familiar with different surfaces such as ivory and ivorine, which require particular paint handling techniques.

Here are seven phrases I like to use when talking about painting in watercolour:

Floating on
The first application of watercolour wash, applied with your largest brush.

Lifting out
This means lifting some of the newly applied paint to make a lighter area. It is done with a damp brush, and will help reshape any form, skies, clouds, hair, petals and so on, leaving a soft edge. Adjust the size of your brush to the size of area you are working on.

Dropping in
Placing fresh colour onto the surface while the first layer of that colour is still wet. All sizes of brush can be used to do this, and it will help deepen the colour.

Picking out
This means using a smaller brush to remove an excess amount of paint. It's invaluable when the small area you are working on has become overloaded with colour.

Sharpening up
Getting a clean sharp edge in some areas, using small brushes to accentuate the main features.

Stippling
Stippling means placing very small dots of paint on top of a basic wash of colour to produce gradations of shape and colour. The effect is used to heighten interest in parts of a painting and establish a careful control of tone on areas such as the inside of flowers, the curve of a leaf, shadows, etc. It can also be used in backgrounds. (See the example on p. 38.) It is a very subtle effect which needs a steady hand, fine brushes and a confident approach.

Hatching

Hatching describes lightly placed, but firm, short strokes, which are very effective for creating backgrounds. The strokes can be applied in any direction but need to be consistent in direction within any one painting. Hatching is a technique which requires patience, and a thorough knowledge of colour mixing to be successful, but it's a very useful skill for miniaturists. (See example on p. 38.) A cosmetic brush can also be used effectively.

A miniature in watercolour on paper

Miniatures aren't easy to paint on the spot. Often it's a good idea to concentrate by sketching in pencil, using an aperture cut to the size of a miniature to help you decide on a composition.

Always develop the sketch into a slightly more detailed drawing, establishing shapes, a few darks and shadows and some detail. This first sketch serves as a guide to the next stage when you begin to work in colour. Have your paints and brushes ready with a jar of clean water. Place any reference material close to hand, and pin your initial drawing close to your painting. Later, when you work on ivorine or ivory, you will be able to place your sketch under those materials and use it as a base for your second stage.

You may find it helpful to analyse my miniature 'Crookhaven Harbour' from sketch to finished picture.

DEMONSTRATION

CROOKHAVEN HARBOUR

Watercolours: cobalt blue, rose madder, Paynes grey, lemon yellow, light red, cadmium orange, vermilion
Hot press paper; brushes: ooo and 3; white saucer for colour mixing; rectangular cardboard cut-out, 7.5 × 4.5 cm

METHOD

STAGE I The pencil drawing helped me to outline the main shapes, and the placing of boats and figures. I knew the placing of reflections and shadows needed to be thought out in advance, as these are danger areas, particularly when painting with watercolour on paper. If these areas aren't fresh in colour they can look very grey and muddy, so I needed a few strokes to define them.

STAGE 2 I transferred the pencil drawing by using my 000 brush and a thin mixture of cobalt blue, just tracing the outline of the main shapes, the distant hills, middle ground, church, harbour wall and I lightly indicated the boats and figures. Starting with the sky I worked downwards by taking my size 3 brush and mixing cobalt blue with a good amount of water. Then, beginning at the top left I floated on the sky, trying not to lift my brush until I had reached the hills. Then, washing my brush quickly in water so it was free of any colour, I lifted out the shape of the clouds. While the paint was still damp I dropped in little specks of rose madder and cadmium orange, pushing them gently into the cloud space to give a warm glow and more shape. A mixture of lemon yellow and Paynes grey, which makes a pleasing green, was then floated onto the hills. Rose madder and cobalt were mixed together and then floated into the space between the hills to convey the sense of recession.

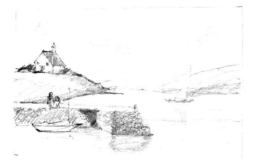

Stage 1

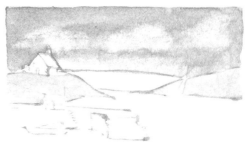

Stage 2

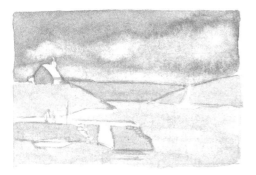

Stage 3

Stage 4

STAGE 3 I now established the shape of the tiny church and harbour wall with a mixture of cobalt blue and light red, still using my size 3 brush. I was careful to leave the small areas where I wanted to work up more detail clear of any colour – the harbour steps, the section which caught the warm orangey tones and the boats. The sea was another wash of cobalt blue.

STAGE 4 To finalize this little painting, I picked out some of the colour in the distant hills with a wet brush loaded with clean water. I reshaped the sails too and picked out their reflection in the sea. I gave it enough time to dry and then began to sharpen up the detail with a stronger mixture of the colours. I did this with my 000 brush, using cobalt and light red for the tiny crevices in the harbour wall, the detail on the church and for outlining the figures. I floated on a mixture of cobalt and cadmium orange to arrive at a soft green for the mossy effect across the stones in the wall. Again, this mixture was just stroked across the nearest hills. I quickly filled in the church, sharpened up by drawing with a fine brush and left the vermilion boat and tiny red flag to the end.

Always move away from your painting, even if just for a few minutes, then return and you are sure to see where some slight improvement can be made: a tiny shadow thrown by the figures, a stroke or two to deepen the reflections in the water, and so on. But be warned, overworking a painting in watercolour on paper can lead to a muddy effect, so don't overdo your last stages.
 'Crookhaven Harbour' would look well with a narrow cream card mount (mat) and a light wooden frame.

Painting on ivorine
For the watercolourist, ivorine has many advantages, and it is now more popular than leaf ivory with many miniaturists. It will seem a strange surface, however, when you come to it after having previously worked on paper. Watercolour will pass from the tip of your brush and rest in the shape you have painted but it won't be absorbed as it would be on paper. However the colour dries quickly and further colour washes can be applied on top. Errors can be eliminated easily; a carefully controlled clean brush, filled with water, can be used to remove any unwanted build-up of colour, and you can manipulate and remove colour persistently without spoiling the spontaneity of the painting. It helps to know that if anything goes wrong you haven't lost every-thing, and it may be that you will achieve a more pleasing shape after correcting. If

things go badly wrong, the whole picture can be washed off by wiping with a damp rag, or just holding the ivorine under a running tap.

In the beginning, you need to practise and get the feel of how to apply the basic washes. Once this is mastered, you will quickly discover what a delightful surface it is to use.

Loading the brush with paint can present problems: practise and observe the amount of watercolour needed to be just right – not too much, so the water is dripping, not too little so that the colour 'scratches' onto the surface. At first it is easy to overload the brush. Bear in mind that the tip of the sable brush should be guided by your hand with a feather-like touch.

This is a good time to experiment with some colour mixing and try out a basic exercise. You'll need your brushes, a small piece of ivorine and paints.

First prepare the ivorine by washing it in detergent to remove any grease. Always hold it by the edge so that your fingers don't touch the surface. Dry it with a soft cotton rag and rub down gently with fine sand paper, to give the surface key. Attach it to your drawing board with tape.

Make several small drawings, perhaps egg shapes, or circles and begin to fill these with pure colour washes. Watch the amount of watercolour actually in the brush and, resting your wrist on a piece of paper, move the brush gently from one side to the other. Don't hurry and be careful to just touch the very edge of the previous area of colour when you return to make your second and subsequent brushstrokes. The secret of a good wash on ivorine is not to lift the brush until the area is covered; if you do lift the brush mid-wash you'll produce a blob. Let the colour dry and then, with a smaller brush, lift out some of it. You can easily establish clean edges by wrapping a small piece of cotton cloth round the handle end of your brush, and using it like a pencil to redraw or reshape an area which needs attention.

DEMONSTRATION

LITTLE DUCKLING
(watercolour on ivorine)

Before you begin, plan your working time and don't rush into the exercise. Painting this duckling will help you come to terms with miniaturization, give you a chance to practise your washes and use the brushes. You will see that I keep using the

seven key expressions mentioned earlier and the seven main stages are worked through.

Watercolours: cobalt blue, cerulean blue, vermilion, raw umber, Paynes grey, rose madder, light red, cadmium orange, lemon yellow, white designers gouache
Brushes: 000, 00, 0, 1, 2, 3, 4; piece of ivorine 6 cm square; circular cut-out 5 cm in diameter; paper; pencil; masking tape; water jar; blotting paper; clean white rag

METHOD

STAGE I Sketch the duckling with pencil onto paper; keep placing your circular aperture over this to help arrive at the correct size. With a soft pencil (3 B is OK) simplify the outline. Don't be concerned with form or shadow at this stage.

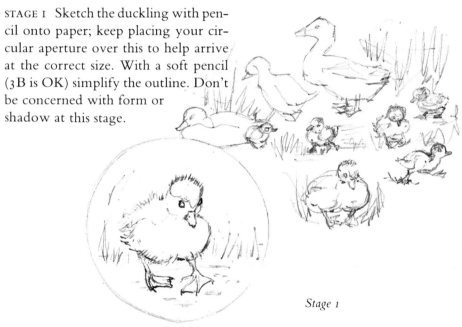

Stage 1

STAGE 2 Wash and prepare the ivorine and attach it with masking tape over the drawing. Have the blotting paper beneath your hand, as you must try not to touch the ivorine once it is clean of any grease. Press down slightly and you will be able to see your drawing in pencil.

Take the 000 brush and mix a little cobalt blue, then draw the basic shape of body, head, beak and feet in fine outline. By doing this you will become familiar with the

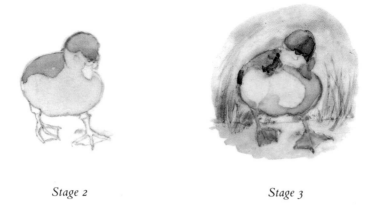

shapes and it will help you apply the washes. Correct any drawing, noting angles and features, such as the beak, the eye and the manner in which the webbed feet are turned inwards.

Always mix plenty of colour. Now, mix lemon yellow and cadmium orange and, taking a size 3 brush, float this paint over the front of the body and the front of the head. Leave the head and wings for the moment. Lift out just where the highlights come and let the wash dry. Paynes grey and cobalt blue mixed together make a softer colour than black for the duckling's back and the top of his head. Float this on, letting it come up against the yellowy tones. Lift a little of the yellow into the darker sections to get a soft edge. Mix vermilion and light red for the beak and feet. Paint these in with a smaller brush. You now have the simple basic shape and colouring of a duckling, and are ready to build up further tones and textures.

STAGE 3 Mix cobalt blue and light red together and establish the ground beneath the duckling. Again your drawn blue edges act as a guide. Now begin to deepen the tone to give roundness to the body. Mix raw umber and cadmium orange for this and delicately float over the basic wash in the shape of the shadow under the duckling. Note the shadow on the side of the head and between the legs.

Try to keep the work fresh and think about the shape that would be beneath the feathers. Remember, also, how a drawing can be recaptured and corrections made with a damp clean brush.

Your duckling now has a shape and some form. A thin wash of cerulean blue indicates the sky and a mixture of Paynes grey and lemon yellow will give the first indication of the grasses.

STAGE 4 The picture now needs to be strengthened by sharpening up with a fine brush. The brush needs to be fairly dry and the colours mixed to a darker tone. First mix cadmium orange and raw umber together and begin to stroke this mixture on in tiny sharp strokes to give the first feeling of feathers. Strokes of Paynes grey added to these will give an effect of depth.

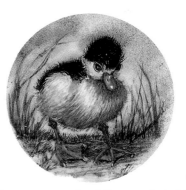

Stage 4

Work further on the grasses. A fresh, lighter green mixed from cobalt blue and lemon yellow can be painted on top of the first long shapes of grass. Then outline the grasses with Paynes grey and lemon yellow to bring the tones together.

Now return to the beak and feet and stroke light red into the darkest areas. Keep the edges sharp. Place shadows beneath the feet and float a deeper, stronger mixture of rose madder and cobalt blue to indicate further shadow on the ground. Work again on the shape of the body, getting deeper tones with tiny strokes all the time.

Flick a little cadmium orange outwards from the body towards the back to break the line and merge the colour, then, taking Paynes grey and still with your small brush, stroke and lift outwards to indicate the broken edge of feathers. Shape up the feet with a little more detailed drawing and lift out some colour where you think it necessary, drop in more where you feel it would be effective. Pick out areas that may have got over-worked, sharpen up the detail and try out a little bit of stippling for the eye and a little bit of hatching round the beak. Finally, sit back and look at your duckling from a distance. It will need a stroke or two here and there but take care not to spoil it. A little designers gouache in white can be carefully placed in the curve of the eye and the highlight on the beak.

Don't cut out your picture until you are sure you have finished, then think about how you would like it mounted and framed. This picture would look good with a cream mount (mat) and framed in wood. Don't forget to sign your work. This can be done discreetly, usually in the lower right-hand corner.

If it works

If all has gone well, and I hope it has, you will have made a lot of progress in a structured way. You will have established an outline by using a small brush and thin

colour and have floated on the correct amount of watercolour to fill the space and give it a clear and smooth appearance. You will have kept your hand on the move without raising the brush. You will have planned each area and thought out your basic colours. You will have built up colour on colour carefully, lifted out colour in areas, dropped in more colour, sharpened edges and learned when to stop.

If it hasn't worked

But you may have had a few problems – just as helpful when learning, so don't be discouraged. Firstly, you may have given the brush too much to do in the first application of colour, trying to cover too large an area. So, again, plan the spaces and outline them. Your brush may have been too dry, with not enough watercolour in it, so that the wash would not float on smoothly and the effect looks 'ridged'. You may have overloaded the brush with too much watercolour, which will have left one side looking much darker than another. Again, remember the water is passing from the tip onto your surface with a light touch and that you are actually manipulating a 'puddle' of colour – keep it on the move within the outlined area and try and manage the initial wash with one brushload. Later, you will find there are occasions when the area to be covered is too large for one brushload of paint, such as when painting the background area behind a portrait, and any tiny hard lines left are usually disguised with the stippling and hatching techniques.

You may have accidentally brought about what I call a 'happening' and manipulated your puddle of colour so that you get exactly the right gradation of colour – even if it's inadvertent! No miniature wants to look too dark too soon, and it should never be ridged or scratchy in appearance, but there are times when you just hit upon the right effect even when it wasn't exactly what you were trying for. You need to a be a bit lucky for this to happen, though!

Oils

All the rules we have discussed as to size and framing apply to miniatures painted in oils. Whether you are an experienced oil painter or a complete beginner, the main advantage this medium has over watercolour is that mistakes can be painted over and tones corrected. You may have been used to working with larger brushes and in a broad style, but your technique can be adapted to making well placed but smaller strokes with a smaller brush. Oils do require a bold approach; there doesn't want to be anything tentative about your strokes. But because the surface to be covered is small it is a grave mistake to think it can be covered quickly. A great deal of time

and care are needed, particularly when applying paint to a surface. It is tempting to 'worry' the paint by pushing the brush into it once applied. Muddy colours arrive that way. It's best to mix colours carefully on a ceramic tile and then apply with a sure touch so that you keep the work alive.

Look back at chapter 1 for details about surfaces and equipment suitable for oil painting in miniature. Refurbish your paintbox and keep your sable brushes separate from other equipment used for larger work. A piece of clear plastic is useful to cover your working area. Rags and turpentine will be needed, and you can do with at least two small dippers. A drawing board will do instead of an easel, as you will be sitting down. Plan your working day well, as oils take just that bit longer to set up and clear away. Always leave enough time to clean brushes properly and leave the area tidy.

Oils do have one main drawback – they are slow to dry. A vital piece of equipment when painting in oils is a small wooden 'bridge' which can be quickly constructed from a short length of plywood 28 × 8 cm. It should have small bars at either end to lift the hand away from the work, so you don't smudge the paint while it's wet. The bridge rests across the painting and it will take a little time for you to adjust to resting your hand on it, while moving the bridge up and down the work.

The palette I recommend to start with is:
cobalt blue, French ultramarine, raw sienna, viridian, rose madder, burnt sienna, Indian red, yellow ochre, lemon yellow, Paynes grey, vermilion, chrome yellow, titanium white. Further additions could be: *Rose doré, terre verte, cadmium red* and *cadmium red deep, permanent magenta, black, Winsor orange.*

1 cobalt blue
2 French ultramarine blue
3 chrome yellow
4 yellow ochre
5 lemon yellow
6 raw umber
7 burnt sienna
8 Indian red
9 Paynes grey
10 viridian
11 vermilion
12 rose madder
13 titanium

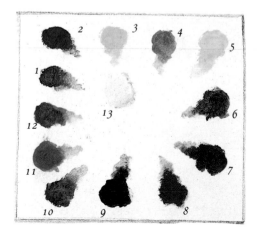

*Brushes
sizes 3, 2 and 1*

*White tile for
mixing colours*

Paints can be preserved from one day to the next by covering the palette with a sheet of plastic, but make it a rule that you only squeeze out the quantity you think you'll need, so that you don't waste paint.

There are various expressions I use when talking about oil painting in miniature:

Blocking in
This technique is comparable to the 'floating on' method used in watercolour; it means filling in an area which has previously been outlined.

Rubbing in
Oils mixed with turpentine are applied with the largest brush in a fairly broad way, and while still wet a cloth can be used to rub in the colour. This leaves a softer feel on the surface, which will later be ready to take more detail and finer strokes.

Dabbing
By using a rag, some of the colour is dabbed off, so that the colour merges softly with the one next to it.

Stroking on
This means using short strokes to give texture and shape.

DEMONSTRATION

KITTEN AT PLAY
(oil on ivorine)

This is probably your first attempt at painting on ivorine – and you will be painting in a thick medium on a very smooth surface. The surface will seem slippery and will need preparing with a little sanding down to give key. A thin application of colour should be used at first.

> *Oils: cobalt blue, cerulean blue, Paynes grey, lemon yellow, chrome yellow, vermilion, viridian, Indian red, titanium white*
> *Piece ivorine 12 × 9 cm; brushes: sizes 1, 2 and 3; rags; turpentine; dippers; ceramic tile for mixing paint on; masking tape*

METHOD
STAGE I Make a pencil sketch of the kitten, on paper about 9 × 16 cm; you could use one of your cardboard cut-outs to help. Take careful note of the lift of the tail and

angles of the paws. Begin by drawing the basic oval shapes of the body and head, and also think about the direction of the fur. Draw the whole hat, which extends beyond the kitten's head. This way, the small curves of the brim will come in the correct place. Look for the negative shapes between the paws, which helps to position the paws correctly. Use the tip of the ear to find the edge of the bow. Keep it as simple as you can, no shadows, just a good bold outline.

Stage 1

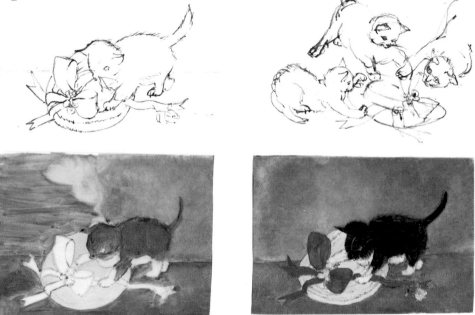

Stage 2

Stage 3

STAGE 2 Place the ivorine over your drawing and attach it firmly with masking tape across the top. You will be able to see your drawing through the ivorine. Trace the outline in cobalt blue with a size 1 brush. Mix cobalt blue for the background of the painting, thinning it down to a soft shade with the turpentine, using a size 3 brush. Paint it on; it will look streaky at first but by using the rag and rubbing gently, a soft colour and a smooth but matt surface will be left. Then mix Paynes grey and cobalt for the kitten's body. Apply this thinly and then rub it in gently. Do the same with a mixture of lemon yellow and white for the straw hat.

STAGE 3 With a size 2 brush, Paynes grey and cobalt blue, stroke on the kitten's fur, remembering that it is growing *outwards*. Leave the breast and paws white. Apply vermilion for the ribbon and cerulean blue to divide the background and form a shadow under the kitten. If the base is dry the colour will not slide about as it may have done with the first application. Begin work on the straw hat by looking for the tiny dark ridges in the straw and stroking on a mixture of Paynes grey and cobalt. Now strengthen this with a thicker application of white and lemon, and while it is still wet dab with a little rag to obtain some texture. Paint in the roses, noting that they match the hat and are separated only by the darkened edge. Viridian and lemon yellow will make bright leaves.

You will be using thick paint so don't overload the brush. It is better to keep replenishing the colour and keep the brush to a fine point than have the sable hairs look thick and chunky with paint. Begin to rework the fur with small strokes, placing your brush well into the body and lifting it towards the edge, which takes it across the background. If it looks too heavy, dab the colour in again and then work up the texture. Try not to lose the edge; it needs to look crisp but be broken by the fine tips of fur.

STAGE 4 More Paynes grey and cobalt will help the colour and you could flick a little Indian red into the form. It will look good amongst the darks. Still with the

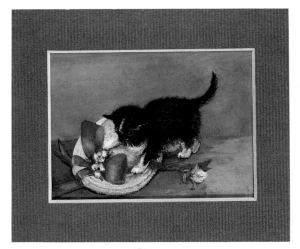

Stage 4

small brush, reshape the bow and ribbons and work on the roses, darkening the centre. A spot of chrome yellow will lift the edges. Cobalt blue in fine strokes will throw a good sharp edge round the straw hat; notice where the sharp shadows of the ribbon fall against the straw. Finally, place in all the whites, the paws and feet, the whiskers and edge of the eye. Note, too, how meaningful small dark strokes applied in strong colour can establish areas such as the edge of the ribbons.

It is best to leave your small oil paintings for a few days until they are thoroughly dry before framing them. A blue mount (mat) seemed right for this miniature, and I think a narrow gilt frame would enhance the painting.

You could also try painting this miniature in alkyds – see pp. 40–3.

DEMONSTRATION

FOAL IN SUNSHINE

(oils on fine linen)

Oils: the palette suggested on p. 29, without the additional colours
Brushes: sizes 0, 1, 4; white ceramic tile for laying colours on;
rags; two dippers; piece of fine linen, stretched over a card, 8 × 6.5 cm.
This will need two coats of acrylic gesso primer to give it a good surface.

METHOD

STAGE 1 I sketched the scene in pencil, being careful to position the foal correctly. Note the way the long legs have settled into the grass, and the lift of the head, as if the foal were looking for his mother. I liked the feeling of golden sun on the expanse of grass and the pleasing yellows against the brown of his coat. When I first spotted the foal in a meadow he was in fact much nearer a fence, but I decided to put him further into the shade.

STAGE 2 I transferred the drawing onto my linen surface with a size 1 brush and a thin mixture of cobalt blue and turpentine. I used cobalt blue in a slightly thicker mixture and the size 3 brush for the sky and blocked that in. Then I settled on

chrome yellow for the sunny area of the grass, viridian and raw sienna for the foliage, and I used French ultramarine with a little rose madder for the distance between the trees.

STAGE 3 I tried not to work in too much detail too soon, and kept the strokes clean and sure. I kept the foal a simple shape to begin with. The paint mixture for his coat was burnt sienna and Indian red. Yellow ochre and chrome yellow were then mixed and stroked on to indicate the shapes of the shadows and a further mixture of viridian and lemon yellow placed with a size 1 brush into the foliage. I then merged a little white with the blue for the clouds and left it to dry.

STAGE 4 The final sharpening up was exciting to do. The tiny well-placed strokes in the correct colour are what do the trick. I left details such as the eye and tail to the end and concentrated on deepening the foliage and painting in the grass.

Vermilion and chrome yellow were mixed together and placed on the foal's coat and neck to catch the light. I thought the tail should be very dark so I used Paynes grey. The mare also needed this colour and I was careful to reshape the neck as well. Finally a brush with a mixture of yellow ochre and white in it was used for placing tiny points of light in the grass and across the foal's body.

A plain, light wooden frame suited this miniature well. Like *Kitten at Play*, it could equally well have been painted in alkyds.

Tracing

Graphite marks the delicate surface of vellum, and doesn't want to be used on ivory or ivorine if possible. So when you start miniature painting it is helpful to know of this method of transferring a drawing onto your chosen surface. Fix tracing paper firmly over your pencil drawing, and tape it down along the top edge. Trace the drawing with a very sharp pencil. Turn the tracing paper over and re-outline the drawing with a coloured pastel pencil or a water-based crayon – blue is ideal. Turn back to the front side of the tracing paper and then place the tracing paper over your surface. Use a hard pencil, or a ballpoint pen and retrace the drawing. The coloured crayon or pastel line will appear on your working surface and act as an excellent border for your first washes of colour.

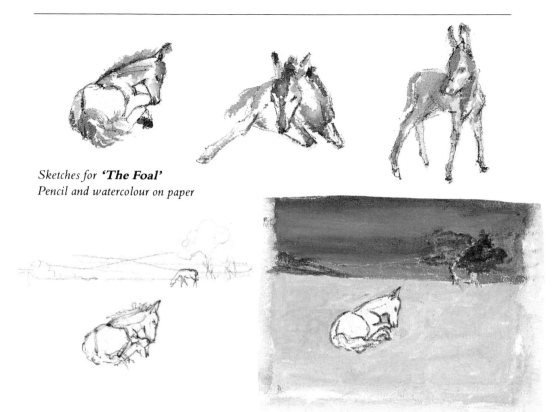

Sketches for **'The Foal'**
Pencil and watercolour on paper

Stage 1

Stage 2

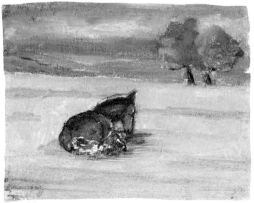

Stage 3

Stage 4

3 BACKGROUNDS NEED NOT BE A PROBLEM

Often the main subject, be it portrait, flower, still life or whatever, will be nearing completion before any thought has been given to the background. Yet it is an important part of the miniature and the space needs to be used thoughtfully. The tones and colours of the principal objects in the foreground need to harmonize with the rest of the miniature.

A few words on the vocabulary used in the book which may otherwise be confusing. I use 'tone' to mean the variation in shade and depth of any one colour. I use 'value' to describe the intensity of a colour. By 'harmony' I mean the establishment of a pleasing relationship between one colour and another.

If you plan the colour of the background in the early stages of the painting, the main subject and the background will be worked on together, and you won't be left with a well-finished foreground and the worry of what to do about the background. Have the colours mixed so they can be applied as you go along and it will keep the interest alive. No part wants to be boring to do, and it's best to get every part of the painting established before finalizing any one area.

As a general rule, the main subject needs a pleasing contrast in other parts of the miniature. Warm colours need cool colours, lights need darks. The contrasts must harmonize, and as shadows are usually blue or green in tone, these colours can often be used as effective complements in a background. Blues look well in portraiture and so does green, but they both need an attractive contrast in the clothing. The foreground in a landscape needs to harmonize with the sky.

The background should always enhance the miniature. Details need to be well drawn and not be intrusive. You can use particular settings to establish a mood, or, with portraits, make connections with the subject. Victorian portrait miniatures often feature thick drapes in the background, which are often not appropriate in contemporary paintings – but an interior with personal items included can be telling. Gardens and trees can be attractive in portrait backgrounds. Nothing, however, wants to look too contrived.

Many subjects, (particularly still life) need a pale background to throw the objects into relief. A dark background, will show light articles to advantage, of course.

A spray or design of flowers will need some contrasting colour behind the petals and leaves. A blue-grey, mixed from light red and cobalt blue will merge gently and take away something of the white surface. This colour combination is also good behind a single subject – perhaps a bird and foliage, where a blue sky would detract too much from the subject.

In portraiture, a fair-haired person needs delicate tones in the clothing. If you choose a sky for background, keep it light and simple, with a hint of the colour of the clothing dropped into the clouds. A dark-haired person will need darker clothing and heavier tones in the background. Some small part of the colour used needs to be placed elsewhere, but very subtly.

Aim for harmony in colour – and you will probably find it best to avoid strong contrasts. Fortunately, on most of the surfaces used in miniature painting, if a basic colour scheme does not immediately harmonize it can be wiped or washed away and a fresh start made.

Establishing a good working order helps to integrate all parts of a picture. First, do the drawing, getting the composition correct and to scale, plan the colours and carefully place the first thin washes within the drawn shapes so that you have a picture which has some colour all over it. You can then establish your darker tones, continuing to work on all of the painting, so that it reaches completion with the background and subject well balanced.

Watercolour

The illustration (on p. 22) shows a simple wash applied in cobalt blue with small areas lifted out for a cloud effect. This is a useful background for a variety of subjects, landscapes, flowers, wildlife, pets and portraits.

Stippling and hatching, described in the previous chapter, pp. 20 1, are also invaluable effects. You can practise these techniques separately. One way of getting a stippled look is to use a small piece of cosmetic sponge. It must be dipped into the paint, squeezed dry and the colour transferred to the surface with a series of 'dabs'. Take care not to press down too hard or the colour will be lifted off. This method can be used before a final finish to a background is worked with a fine brush. There isn't the same control as when using a small brush, but you'll find practice makes perfect.

1 Hatching – small fine strokes on a colour base.

2 Stippling – small dots on a colour base.

3 Fine sponge on colour base.

4 Aspect of portrait sitter can be added in background.

5 Dark shapes painted on the reverse help establish form.

A very useful way of establishing backgrounds is to paint on the reverse side of ivorine and ivory. These surfaces are translucent enough to allow a glow of dark colour to show through. By turning the surface over onto its reverse side and holding it up to the light, the initial drawing can be seen and when the painting is placed against a white sheet of paper, the colour on the reverse side will show through. A large flat coat of deep tone can be painted on the reverse like this, which may be very helpful. The front surface, however, still needs a thin wash of colour or the surface will look unpainted. Don't let any work on the reverse side dominate the delicate tones of painting on the front, or false shadows will be indicated. Painting done on the reverse side must be well-shaped and act as a guide to the placing of colour and tone on the front.

Oils and other mediums

Although painting to a miniature scale, you need not be inhibited about the application of colour on the surface – simply take the nature of the surface into account. If working on canvas the texture will show, so it is best to keep the background very plain and use the texture to effect. Methods such as stippling, hatching and using the little sponge can be used effectively with oil paints, and on all the surfaces discussed in chapter 1. The subject will also affect the style of the background – for example, in a landscape where the trees are painted in a lot of detail, the sky behind can be simply painted. Avoid over-complicated effects – say, stippled trees with a stippled sky might prove just too much.

When painting in oils on ivory or ivorine you can paint on the reverse, as described above, but the problem will be letting the paint dry – this could hold you up, so do bear it in mind if you decide to try the method. Gouache could be used which would dry more quickly.

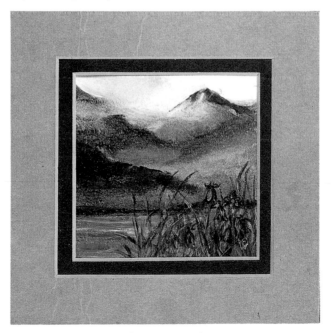

'Misty Mountains'
oil on laminate

4 COLOUR AND METHOD: ALKYDS AND ACRYLICS

Alkyds

Both alkyds and acrylics are now widely used by miniaturists, and offer many advantages over both watercolours and oils. If you haven't used these paints before you may enjoy trying them out. When painting miniatures we start with thin colour and gradually build up a depth and richness of colour, always preserving as much as possible of the translucent quality of ivory or ivorine. Alkyds allow us to do this rather well.

Alkyd colours are made from pigments suspended in alkyd resin and white spirit. The resin is chemically produced from natural plant origins and is exceptionally clear. This allows the full brightness of the pigment to show through – unlike oils where the pigment can be affected by the colour of linseed oil. White spirit or turpentine is used to thin the paint, and brushes are cleaned with these, or placed in a solvent called Sansodor.

The great advantage for the miniaturist is that alkyds dry quickly. Oils may take days to dry and, as the miniaturist works so closely over the painting, it can easily be smudged. However, as alkyds do dry so quickly, it's worthwhile having your working drawing and colour notes worked out well in advance.

Alkyd colours appear startlingly bright when placed on the palette, but subtle tones can be mixed. The quality of the paint can also be affected by the addition of various mediums. Two widely available mediums are called Liquin and Wingel. Liquin thins the alkyd and increases its translucency and Wingel seems to thicken the alkyd paint slightly, making it feel chunkier on the brush. You don't need to use any of these mediums, but if you are interested you could experiment and see how their use affects your brushwork.

The range of alkyd colours is very comprehensive. You may decide to use a combination of oils and alkyds, using the latter for quick-drying under-painting or for touching up an oil painting which needs just a little more work on it. Alkyds are extremely versatile; luminous effects can be achieved by building up the paint in

thin layers (glazing). Liquin can be very useful if you want to achieve this particular effect. Alkyds dry to a sharp clean edge and can be applied in successive colour layers, gradually building up deeper tones.

All the surfaces used for miniature painting will accept alkyds. Hardboard (panel) will need to be primed; wood will also need priming and several coats of 'acrylic gesso primer' will give a nice key. Oil sketching paper will also be suitable. Alkyds can be worked onto porcelain and glass too, which extends their range of use for the miniaturist.

DEMONSTRATION

STILL LIFE WITH ORANGES
(alkyds on gesso board)

A limited range of six colours was used in this painting. The cardboard surface had taken three coats of acrylic gesso primer before I began painting.

Alkyds: London red, French ultramarine, viridian, London yellow, Indian red, titanium white (London red is similar to vermilion and Indian red is similar to its oil equivalent)
White spirit; mediums Liquin and Wingel; Brushes: sizes 000, 00, 0, 1, 2, 3, 4
Piece cardboard 8 × 8 cm, already primed
Paper; pencil; rag; cut-out aperture 6 × 6 cm; plastic palette for mixing colours

METHOD

STAGE 1 Using your aperture as a guide, first sketch the subject onto paper in pencil, and then, trying not to lose the shapes, transfer to the prepared cardboard surface.

STAGE 2 Then mix viridian and London yellow with white spirit and apply it to the background with the size 4 brush. It will look a bit streaky, so gently rub over the surface while still wet. Indian red and French ultramarine are then mixed with white spirit for the brown foreground; a little gentle rubbing will make it appear smooth and even. Clean your brushes with white spirit as you go along.

The oranges are a rich mixture of London red and London yellow, and are painted with a size 3 brush. Adjust your brush to the size of the area you are covering. I painted French ultramarine straight from the tube to suggest the pattern

on the jug. You must now think about deepening the tone of the table top, so place a few shadows in. A mixture containing more French ultramarine than Indian red will suffice; this time use a smaller brush, size 2. Complete the oranges with another coat and this time while the paint is still wet, dab the oranges with your finger tip. This will lift off a little of the colour and leave a slightly rough texture. White and London yellow can be used for the inside of the orange peel.

Work further on the blue design of the jug and begin to enrich the background with further deeper tones of viridian and London yellow. Paint in the white jug.

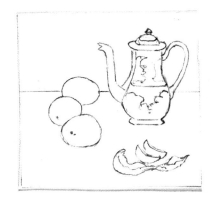

Stage 1

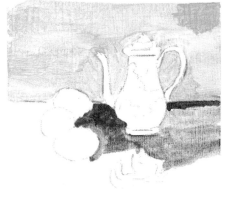

Stage 2

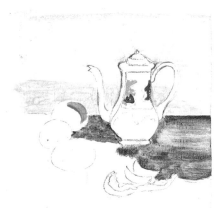

Stage 3

STAGE 3 In this final stage we will use both Wingel and Liquin. Liquin is used for creating a glazed effect, and Wingel for delicate blending and fine brushwork. Place only a small quantity of each on the edge of your palette.

Take Indian red and some Liquin, and float a glaze over the foreground. The Indian red mixture is used in the same way to give a glow to the oranges. Your large brush is best at this stage. Use viridian and London yellow with Liquin for the background.

Begin by placing the shadows and stipple a little to get a good shape, using your ooo brush and a little Wingel to help blend the tones. Finally, sharpen up the edges of the fruit where it comes up against the darks, suggesting the centres with tiny spots of viridian and London red placed side by side.

You will want to brighten the high-lights on the curve of the oranges, so use white and London yellow for this. Use London red to outline the drawing of the orange peel.

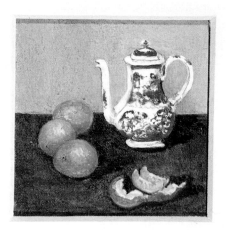

Finished painting

Acrylics

Acrylic paint is made by binding and dispersing pigment in a transparent water emulsion of acrylic polymer resin. The paint dries, leaving a very permanent film and durable colour. Like alkyds, this is a versatile new medium for the miniaturist, as anyone who has worked in watercolour or oils will soon discover. Acrylic paints dry very rapidly, allowing speedy overpainting, and the previous colour won't be lifted off. A 'retarder' can be added to the paint to slow down the drying time, though this is usually used when working outdoors. The paint can also be thinned or altered by the addition of various mediums. There is an acrylic flow improver which increases the flow of the paint on non-absorbent surfaces, and is particularly useful if you want to show hard edged effects. Gloss Medium no. 1 will give an additional gloss to colours when they are dry, but it is not a varnish; Matt Medium no. 2 will reduce the brightness of acrylic colours without producing a gloss effect. Glaze Medium no. 3, used in the clown demonstration, will help produce transparent glazes. Acrylic gloss varnish is a thin liquid which dries quickly to a clear glossy film and protects dry paintings.

Change water frequently when painting with acrylics and it is worth keeping brushes especially for this medium. I personally prefer to use nylon brushes for painting in acrylics. There is an excellent range of colours to choose from, but first,

keep to just a few which really appeal to you. Most surfaces, paper, hardboard (panel), canvas and ivorine will accept acrylics.

As acrylic paint dries so rapidly once out of the tube, only put out a small quantity of each, about the amount used when putting toothpaste on your toothbrush. Keep paints well separated. A quick, home-made palette can be made from the kind of disposable tray on which meat is often purchased from a supermarket. Place a piece of white blotting paper in such a tray and hold it under the tap to dampen well. Tip off the excess water. The paints will not dry so quickly if kept damp, but try and use them all up during your painting session or you'll have to throw away both palette and paints. Some delay in drying can be had by covering this impromptu palette with a dampened cloth and placing it in a plastic bag. Keep brushes in water when not in use and wash them very carefully after painting. Be certain to replace the caps on your tubes, or you may need a pair of pliers to undo them!

DEMONSTRATION

THE CLOWN
(acrylics on gesso board)

Acrylics: white, lemon, ultramarine, cadmium red, bright green, cadmium orange, raw umber, black.
Piece of hardboard (panel) treated with acrylic gesso primer, 15 × 12 cm
(The finished painting was 10.5 × 8 cm)
Glaze medium no. 3; jar of water; paper; pencil; fine-nibbed pen
Brushes: size 0 and 3, nylon (watercolour brushes will do but
acrylics give a brush a lot of hard wear).

The vivid ranges of colours available in acrylics made me think of a clown. I took time to establish the drawing before beginning as the acrylics dry so quickly. I prepared my stay-wet palette and used a large divided plastic palette for actually mixing my colours. You may find you have to rethink your colour mixing as acrylics are so vivid and strong. I prefer to use them straight from the tube and gain effects by mixing with thin glazes: in this demonstration I used glaze medium no. 3, which was ideal for the transparent shiny effect needed for the balloons.

I decided to keep the colours well apart on the stay-wet palette and so keep them very clear. The colours would be applied without a lot of blending. I put ready the glaze medium no. 3 at the top of the palette.

Sketches

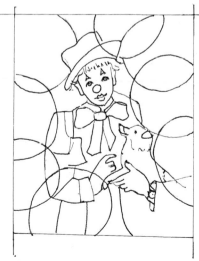

Stage 1

METHOD

STAGE 1 Sketch in pencil, finding pleasing shapes in circles for the balloons. Place the clown's head at an appealing angle and make the dog look upwards (a chance to use your own dog as a model, as I did). I outlined this drawing with a fine-nibbed pen. Transfer your drawing to the surface using the tracing method described on p. 34 and then outline it again with a pen. You will need clear lines as a guide although eventually they will be disguised by colour. Pencil will smudge on the gesso surface.

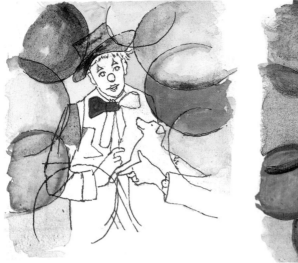
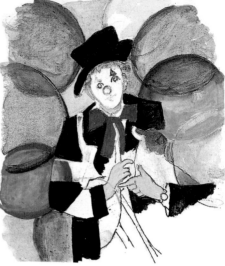

Stage 2 *Stage 3*

STAGE 2 Using bright green and water, and a size 3 brush paint a thin watery wash all round the figure. The balloons will be painted on over this colour. Paint in the black hat with thin paint and you will easily see how one colour reacts when another is placed on top of it.

STAGE 3 Using thicker paint and stronger colours, block in the black patches on the coat and recircle the balloons. Use a little water on your brush and float off the edges towards the centre of each balloon. The green background shows through clearly. Turn your work round as this helps your hand to move more easily when shaping up a circle. Mix a little cadmium red and lemon with white for the hands and use a smaller brush to place these carefully. Keep edges crisp. Paint the face white and begin to outline the eyes in blue.

STAGE 4 Squeeze out medium glaze no. 3 at the top of your mixing palette. You are going to use this with each of your colours, so be sure to clean your brush with water before dipping it into the glaze.

Now is the opportunity to strengthen the colours and discover the transparent effects which can be achieved when they are mixed with a little glaze. I thinned mine with water to begin with so that a thin coating of colour floated across each balloon. It dries quickly and the next balloon's colour can then be floated across.

Lemon is good for lightening the green background as it shines through the balloons. I made sure some of this was reflected in each.

I used cadmium orange for the clown's hair and cadmium red for his nose and mouth, with ultramarine blue for the eyes. A little blue mixed with white gave form to the cheeks. Raw umber and cadmium orange were blended for the dog and I sharpened up the drawing in white. Cadmium red was used for the stripes and bow and I just indicated the fingers and the round red nose, the inside of the mouth and the edges of the watchstrap with a fine brush. With acrylics it is easy to sharpen the edges without disturbing the colour underneath.

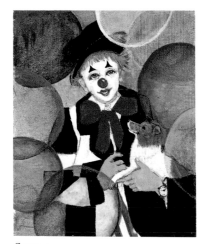

Stage 4

5
PAINTING LANDSCAPES

Landscape miniatures offer many possibilities for experimenting with different sizes and shapes, and all mediums and surfaces can be used. If you have previously painted larger landscapes, the adjustment is mainly one of scaling down, using a different surface and finer brushes.

Miniatures are difficult to paint on the spot – you will need to get back to your accustomed working space and tools, so the sketchbook is vital for taking down ideas and making colour notes.

Every picture will require some sort of plan or design and nature can be overwhelming, so in the beginning simplify everything, both subject and palette. If you use photographs for reference you can select and scale down a subject by using a cut-out cardboard aperture as a 'viewfinder', (mentioned before); moving it about will help you decide on the composition. Don't try to say too much – too many objects in one small landscape will confuse the person looking at the painting. As the artist in control of the plan you can eliminate portions lacking in colour and you can also add touches which heighten and add interest – a bright flower in the foreground, perhaps.

Analyse your painting spatially. Avoid dividing the composition in half – a low horizon looks well, as does a high horizon. To begin with, divide your picture or drawing into three even widths, which will help determine the foreground, the middle and the far distance.

The natural world is full of the subtlest colours and it is tempting to explore all the shades you can. But too many shades can be counterproductive in the painting as a whole – concentrate instead on contrasting lights with darks (shade with sunshine, for example) or think about suggesting atmosphere with different weather conditions; mist, rain and wet ground can all be painted effectively. In a snowscene, a sky can be darkened to bring brilliance to the white foreground.

Details in the foreground require a comparatively greater depth of colour: draw with your smallest brush and paint a little thicker to establish the edges.

Trees and grass

Trees and grass form an important part of many miniature landscapes, so they require some thought. It helps to understand their overall structure – this is obviously very important if they are to be painted in any detail but it is just as necessary when grass and trees are placed well in the distance. Think also about shadows, and the form and shapes made by the direction of the light. At first glance a shadow may appear to be of one colour only, but if you look carefully you'll see several colours reflected there. If you introduce colours into your shadows they will never appear dull.

Good reference books on all types of trees are useful. Study the forms of trees in both winter and summer, and look at the way they emerge from the ground, the way in which the branches grow, how the foliage develops. Note also the light and dark side of a tree and the variety of light and shade created by the foliage.

Grass repays study, too, as it often features in miniatures, and may be shown very effectively in detail in a foreground. So make sure yours looks right – grass needs to be the correct tone and to grow in a natural direction – not absolutely straight! Grass moves in the breeze, and the play of light will show its form. There are hundreds of varieties growing wild, so pick an example and paint it to actual size before reducing to a miniature.

Colour mixing

Studying trees, grass and foliage is an excellent way to practise mixing greens. We look at this in a number of the demonstrations which follow. You will already have been getting experience with colour mixing in the exercises earlier in the book, but it is worth doing a few more experiments with blues and greens. Below, I am talking about colour mixing with watercolours, but you will want to try mixtures in oil and alkyds if you are using these mediums.

Blues

Try working on both watercolour paper and ivorine, comparing the surfaces and the way colours react on them. French ultramarine, cobalt, cerulean blue and Prussian blue all blend well with light red and rose madder. Prussian blue should be used sparingly but it is effective when mixed with light red.

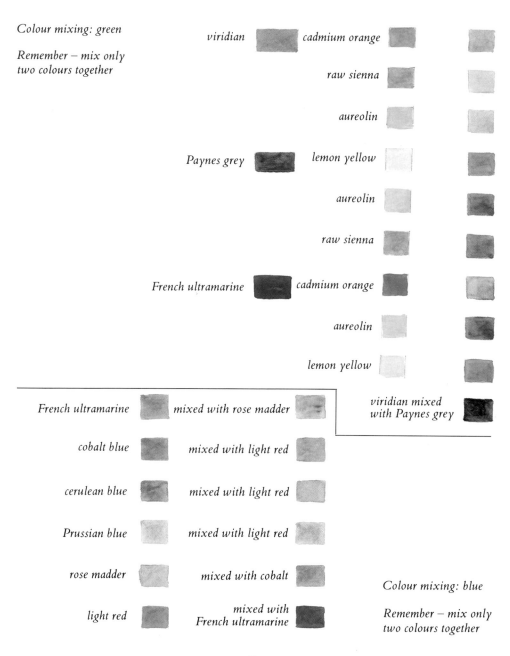

Colour mixing: green

Remember – mix only
two colours together

viridian cadmium orange

raw sienna

aureolin

Paynes grey lemon yellow

aureolin

raw sienna

French ultramarine cadmium orange

aureolin

lemon yellow

viridian mixed
with Paynes grey

French ultramarine mixed with rose madder

cobalt blue mixed with light red

cerulean blue mixed with light red

Prussian blue mixed with light red

rose madder mixed with cobalt

light red mixed with
French ultramarine

Colour mixing: blue

Remember – mix only
two colours together

Greens

Again, it's worth applying colour to both paper and ivorine to compare their behaviour, as paper absorbs the colours and ivorine allows you to manipulate the watercolour, reshaping the form it takes while the paint is still moist. Keep the colours fresh when you want to give the impression of foliage: only mix two together. I find viridian useful; although it seems almost unnaturally bright, it is a shade which appears amongst greens in foliage in bright sunlight. It also blends well with cadmium orange, raw sienna, Paynes grey and aureolin. Keep viridian in a separate corner of your mixing plate and wash your brush each time you've used it. Paynes grey is very useful but dull on its own; it blends well with lemon yellow and aureolin.

Sky and blues

Trees and greens

Grasses and greens

A house

Colour mixing: blues and greens (see analysis of 'Landscape with Grasses and Poppies')

DEMONSTRATION

LANDSCAPE WITH GRASSES AND POPPIES
(watercolour on ivorine)

This circular picture is a good exercise in drawing, applying a wash and colour mixing. I used various tiny sketches of hills, trees, grasses, flowers and houses, bringing them together into what I call a 'happy composition'.

Watercolours: French ultramarine, cobalt blue, cerulean blue, rose madder, light red, Winsor red, lemon yellow, aureolin, viridian, white gouache
Brushes of all sizes; watercolour paper and ivorine, piece of rag
Piece of ivorine 17 cm × 17 cm

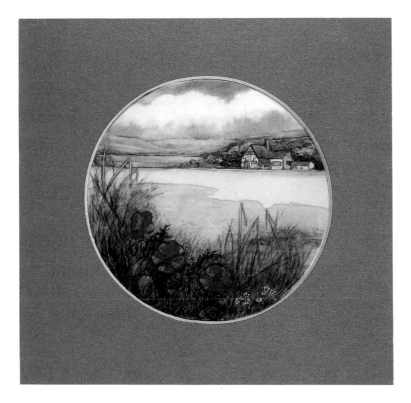

METHOD

THE SKY Skies painted on ivorine are easy. Using your largest brush, very clean water and a good quantity of French ultramarine, float the wash on, stopping at the line of hills. The cloud formation is shaped using clean water to lift out the blue, floating in your brush. You may have to make several attempts, but don't be afraid, as you can easily wash off the whole sky and start again if necessary. While the sky is still damp, drop in a tiny amount of rose madder, swirling it round; then using clean water, do a little reshaping. Then drop in a tiny amount of lemon yellow and let it dry. It is all a matter of mastering the amount of water in your brush. Your small piece of rag will need to be to hand to take out some of the water in your brush as lifting out needs a damp rather than wet brush.

THE FAR HILLS Mix cobalt blue and light red for a soft grey and float the mixture into the shape of the hills, remembering that this is the furthermost point in the picture.

THE MIDDLE GROUND OF SUNLIT GRASS Mix pleasing greens for this area and apply from the edge of the hills well into the foreground. Viridian and aureolin will be an attractive combination here. Let the paint dry, then float a darker tone in to suggest shadow. Next think about the base of the picture and paint in a dark, rich brown for the earth behind the grasses and poppies. Your picture is now established in a patchwork of thin colour and the only part completed will be the sky and possibly the far hills. Carefully draw in the outline of the house.

THE HOUSE Use light red for the roof: note where the shadows come on the house and how clear the white surface remains until a mixture of cerulean blue and light red is painted for the shadows. The windows also have a soft grey tone.

THE POPPIES Here it will be far easier to lift out from a background and then fill in the colour rather than try to apply colour first. This can be done with a damp brush and clean water, provided you know the shapes you want to lift out. In this case, carefully lift out the brown earth in the shape of the poppies and let the area dry, then place in the Winsor red of the poppies. Don't worry too much about getting the shape of the poppies right as you can improve on this in the final sharpening up stages.

THE GRASSES Again, lift out the grasses with a fine, clean damp brush, using only

water on the brush. Then darken the shorter grasses with fine strokes, remembering the way they grow.

FINALIZING THE PICTURE A lot of work is done with clean water and your brushes, without using any paint at all. Sharpen up the drawing of the house round the trees and grasses with a fine brush loaded with fairly dry paint. Be careful of the tones used; don't let these be too strong or dark at first as they can be strengthened later.

Sharpen the grasses and concern yourself with the direction of light on the fall of the stalks. Lift out some of the red of the poppies to give variety to the form and drop in a darker red to establish the shape further. Take care with the tiny centres; a few dark dots will suffice. Look at your picture from a distance and see where it can be enriched with darker tones, particularly in the foreground.

DEMONSTRATION

SCOTNEY CASTLE
(watercolour on ivorine)

Watercolours: cobalt blue, cerulean blue, rose madder, light red, Paynes
grey, yellow ochre, lemon yellow
Brushes: size 000, 1, 2, 3; drawing paper; pencil; water; rag
Piece of ivorine 7 cm × 7 cm

METHOD
STAGE 1 Outline your pencil sketch and place it beneath the ivorine.

STAGE 2 Rub the surface of the ivorine carefully with fine sand paper and place it over your drawing. Attach sticky tape to the top edge to hold the drawing and the ivorine firmly. Mixing a little cobalt blue and, taking an 000 brush, trace the drawing through. Make a thin mixture of yellow ochre and cerulean blue and trace the trees. Hint at the reflection in the water. Sharpen up the outline with a clean brush containing just water, lifting out any lines you aren't happy about. Don't move on to the next stage until you are pleased with the outline.

STAGE 3 Float on a mixture of cobalt blue for the sky, lifting out some clouds. Try cerulean and lemon yellow for the lightest part of the trees and remember to place this same mixture into the front part of your picture. I suggest light red for the castle

roof, and you could drop a little of this colour into the foreground. Note the dark windows, and paint these in. Float a fresh mixture of cerulean blue over the whole watery area and quickly lift out the reflection of the castle wall. Let it dry.

Stage 1

Stage 2

Stage 3

STAGE 4 In the final stages your miniature will need refining, so working with your 000 brush, sharpen up the edges with a little darker paint mixture and think about the curves and shapes of the trees and building. Paynes grey and rose madder give a depth of tone. Build up richer greens in the foreground. This detail is important, so take care with it.

Lift out colour with a damp brush on the sunny side of the castle wall to get a nice fresh light part. Add a darker tone to enrich the shadows where the foliage curves in against the wall.

This is an opportunity to try out stippling and hatching. Stipple a dark green into the base of the castle wall. Hatch a few strokes of the same tone into the trees.

Stage 4

Place your painting where it will catch your eye throughout the next few days. You will be surprised what improvements you will want to make – to lighten the sky behind the castle, perhaps, or deepen the greens in the overhanging reeds. Knowing when to stop can be testing in itself, so if the painting looks pleasing, leave it. You will have learned a lot from doing it. This miniature would look well with a narrow mount (mat) and a light wooden frame.

Scaling down

Scaling down a landscape subject to the size needed for your miniature need not be a worry. There are modern methods, instruments and tools which will help make the work easier. You can use a photocopier, which can be adjusted for both scaling up and down. There is an element of trial and error in this to begin with, and if you are having the work done in a photocopying bureau it helps to tell the operator whether you would like an outline to half or a quarter size.

Begin by making a tracing of the larger version, then transfer it to white paper. The well adjusted photocopier will do the rest. This is a very time-saving method, particularly useful if the subject has a mass of fine detail, such as a ship in full sail where the rigging needs to be carefully painted, or for buildings with complicated perspectives.

A second method, and one that really does help you master drawing skills, is particularly useful when a miniature is based on a larger sketch or painting. A simple grid method is used. You will need a set-square with clear markings on it. Measure the exact size of your larger picture, and divide the dimensions into a convenient number of squares. Decide on the size of your miniature and rule the same number of squares to the smaller scale.

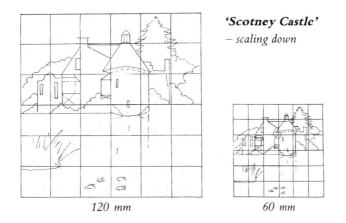

'Scotney Castle'
– *scaling down*

120 mm

60 mm

You can then draw the outline of your work on the larger grid and repeat each section of the outline on the smaller grid. ('Scotney Castle' is used to illustrate this method.)

DEMONSTRATION

LANDSCAPE WITH SHEEP
(alkyds on canvas)

(You may care to re-read the chapter on Colour and Method (page 18) before following this demonstration through.)

I decided to use cotton canvas to express texture in this little painting – the curly wool of the sheeps' coats, the grass and the stone wall. I made various sketches and waited until the sheep settled into a hollow before deciding on their final position; I decided to use the darkened hollow to accentuate their shape. I used a limited palette of six colours.

Alkyd colours: London yellow, London red, viridian,
titanium white, Indian red, French ultramarine
Sable brushes: sizes 1, 3, 4; dipper; bottle of Liquin; tube of Wingel; white spirit
Cotton canvas, 13 × 9 cm; clean rag, sketchbook and pencil;
plastic lid for colour mixing

METHOD

STAGE 1 First, attach the canvas to a piece of firm card with a good quality glue. Get your pencil drawing down to the required scale.

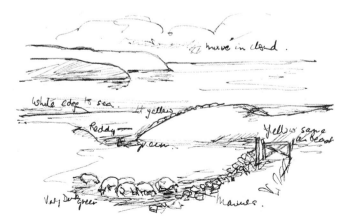

Stage 1

Put only a small quantity of the above colours on your palette; you will need more white than the other paints, so place this in the centre. The colours are strong and you'll have to be careful that they don't seep into the white and lose their vibrancy.

Alkyds are 'buttery' in texture, and dry quickly, so be careful to clean your brushes in white spirit as you go along.

STAGE 2 Transfer your drawing using a small brush and a little colour weakened with white spirit. Try using ultramarine blue for the distant hills and London yellow for the edge of the beach. Mix French ultramarine with white paint for sky and sea, then think where this colour can be reiterated – perhaps a little in the stones on the wall. Mix French ultramarine and London yellow with white to make a green and paint in the shape of the sloping hills with a larger brush. Drop little flicks of this green colour well into the foreground. Outline the sheep carefully in blue, keeping the colour flowing by adding a touch of Liquin to the point of your brush while mixing. Establish the deeper colours, such as the warm reddish glow on the wet beach. One stroke of London red at this stage can be subtly blended later.

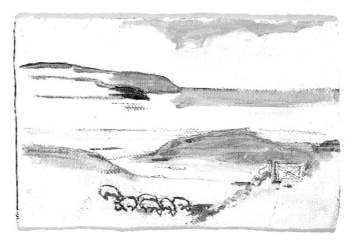

Stage 2

STAGE 3 Add white to the green mixture and lighten the hills in the foreground, taking up a little of the paint already applied. Do the same with the sea, enriching the water with lights and dark blues. London red and French ultramarine with

white makes a pleasing mauve for the distance and this also needs to be placed carefully to strengthen the stones in the wall.

Viridian and French ultramarine make the darker green for the hollow and the sheep are painted broadly in white with mauve to establish some shape. Add white

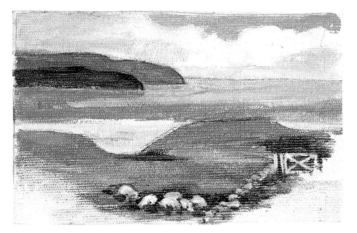

Stage 3

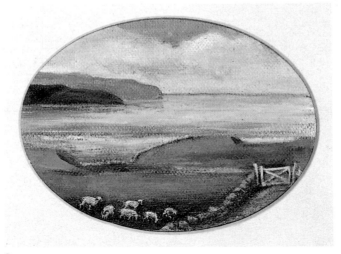

Stage 4

again mixed with London yellow for the beach. At this stage you will really need to decide on all the light and dark tones.

STAGE 4 Indian red and French ultramarine mixed with white can be used to sharpen the edges of the stones and deepen the shadow coming from the beach. The sunlight falls brightly here. I mixed viridian with a little Wingel to make a thin glaze, and stroked this over the whole foreground. It lifted off the paint as I stroked and blended the tones. The sheep only needed a little more drawing, so, using the small brush, I applied deeper tones of green. Finally, I again used the mixture of London red and French ultramarine and white to give movement to the clouds and shape the reflection thrown by the distant hills.

This picture could also be painted in watercolour on ivorine, or in acrylics – sharper drawing and finer detail could be achieved with these mediums on the finer surface. You might try both approaches.

Experiments with oils on laminated surfaces

Very effective miniature landscapes can be painted on laminated plastic surfaces (such as the type used for table tops) usually going by names such as formica or decamel. White is the best choice of colour, and offcuts are sometimes available from builders' merchants. The material needs to be cut with a fine-toothed jigsaw, or with a tile cutter. The size 7.5 × 5 cm is a comfortable one for a landscape in this surface, but you might prefer something slightly larger, say 15 × 10 cm. Ovals and circles are very difficult to cut, so it is as well to have prepared an oval or circular mount to place over your finished work before it is framed.

On the next page I suggest a range of exercises which will help you to manipulate paint on these surfaces.

Oil colours: You can experiment with any of the colours you have; I used French ultramarine, cobalt blue, light red, Paynes grey, viridian, chrome green, chrome yellow, lemon yellow, rose madder, white, red;
formica, decamel or a laminated plastic, cut to the required size
bristle or hog brushes approximately ½ inch across, preferably square; two sable brushes sizes 2, 3
white spirit; Liquin; paper tissues

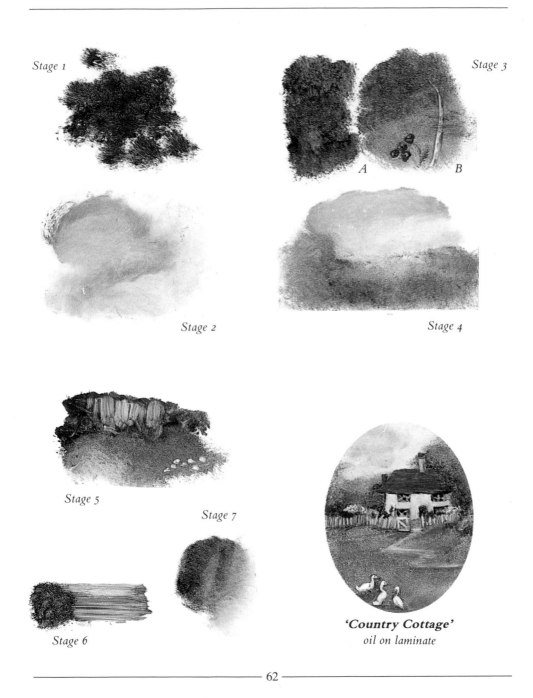

Stage 1

Stage 2

Stage 3

A B

Stage 4

Stage 5

Stage 7

Stage 6

'Country Cottage'
oil on laminate

Skies

Using French ultramarine, load the bristle brush well and push the colour into the surface with short stabbing movements. Leave some parts white for the clouds. Fold two squares of tissue into a small 'parcel', and rub and swirl the colour into the surface. Some colour will settle into the tissue, but the remaining tone leaves a fine membrane on the surface which immediately suggests a soft sky and clouds.

Trees and foliage

Clean your bristle brush frequently in white spirit and load it with viridian; jab it on the surface with the stabbing movement described above. Add a little chrome yellow to your brush and do this again on top. Now soften the green by dabbing with a pad of fresh tissue and see the effect on the overall texture of the greens. Don't use a swirling movement, but dab firmly. This will, of course, lift off some colour but by gently dabbing again and again the colour merges in a very soft, textured way, and the effect is one of tight, close stippling. This stage can quickly be achieved and the various tones and effects will suggest ways in which you can develop the work. Perhaps you could try a second or third application of colour with the bristle brush and more dabbing with the tissue pad. Shapes such as tree trunks, flower heads, fences and so on can be established with a sable brush and Liquin. Draw the shapes, lifting the colour right down to the basic white surface. Such areas can then be painted in very effectively.

Try this simple experiment. Use three colours, French ultramarine, rose madder and viridian to create sky, sunset and grass. Apply the three colours separately, swirl gently with the pad of tissue, then dab into the paint gently.

The bristle brush is useful with this surface as you can boldly stroke away colour and suggest shapes such as fencing, tree trunks, walls and buildings. Horizontal strokes can be useful for suggesting water. Further colour can be added to deepen the edges, which also helps to improve overall definition.

This method of applying oil colours to a laminated surface is particularly satisfactory for landscapes as rendering fine detail of foliage is made easy, and the effect can be very subtle. I myself don't think that the stark whiteness of the surface is very sympathetic for painting portraits, though there is no reason why it shouldn't be used. It's also a good surface for painting fur. Colours can be applied in streaks in the shape of the animal's body, and then dabbed softly so that the colours merge.

'Spring Day'
oil on laminate

6
PAINTING FLOWERS

If you have an interest in botanical painting, working to the miniature scale won't hold any problems, as you will thoroughly understand the form of the flowers. If you have always loved painting and drawing flowers, perhaps to a much larger scale, you will find that they look enchanting in miniature. Many miniaturists choose to specialize in painting flowers.

You will need to observe flowers closely, sketch them carefully and see the shape and formation of the petals, how the stem grows and the formation of the leaves. Be painstaking about this, and you'll find that it will make a real difference to your painting. One useful tip is to draw several flowers, then cut these drawings out and arrange them to form a composition; you could purchase a different flower each week, draw it, and then arrange a beautiful composition in this way. Flowers also look good when painted in sets and displayed in groups, and all shapes of frame are suitable.

Pencil sketch of white star clematis *Sketches of flowers watercolour on paper*

'Flowers of the Algarve'
acrylic on paper

'Little Wild Rose'
watercolour on ivorine

DEMONSTRATION

SUMMER BOUQUET
(watercolour on ivorine)

Watercolour: rose madder, Payne's grey, cerulean blue,
cobalt blue, cadmium orange, white and black designers gouache
Brushes, sizes 000, 1, 2, 3; ivorine 8 × 8 cm; paper, pencil; water; rag

METHOD

STAGE 1 Sketch the flowers in pencil on paper, moving the shapes about until you have a pleasing design. Don't worry about lights and darks, yet. Have an outline done with an HB pencil ready to place underneath the ivorine, or you could trace the drawing through as explained on p. 34.

STAGE 2 Outline each bloom in thin colour. I used rose madder for the wild roses, cerulean blue for the bluebells and so on. A mixture of cobalt and cadmium orange for the leaves will register the greens at this stage. You have time to change your mind about the composition when working on ivorine, so wash out any part that doesn't look right, and redraw it in paint.

STAGE 3 You now have plain basic shapes outlining your flowers, so begin to mix and apply your colours; rose madder for the wild roses, cobalt for the blue, leaving the white flowers with a delicate blue outline. Don't let your painting get too advanced before deciding on the background. The application of a dark colour could disturb the careful placing of your flowers. A subtle shade of grey placed in a circular shape on the reverse side of the ivorine will show through as a softer grey, and will be just enough to give the centre of your painting some interest. Even though this colour is placed on the reverse, don't let it be invasive, for you want to use delicate shading on the petals.

I decided to use black designers gouache and mixed this into a good-sized puddle. I then took my largest brush and floated it on, being careful to control it as it came up against the edges of the flowers. I quickly lifted out any overflow and let it dry well before sharpening up the edges.

STAGE 4 The final stage is always exciting, bringing the painting together with a fine brush and fine detail. Look for the darker greens as the leaves fold behind the flowers, and stroke fine lines into the petals. Cadmium orange makes a bold centre for the wild roses,

Stage 1

Stage 2

Stage 3

and a mixture of rose madder and cobalt can then be painted in with a little stippling to give stronger meaning to the circular edges. Leave everything understated rather than making the painting look too thick.

White must always be used with great caution in a miniature but I allowed myself a good mixture to give a stronger effect for the little white flowers against the black background. Finally I used a little trick, and scraped off the shape of the curling fronds of foliage, getting right down to the ivorine; into this area I painted a nice fresh green.

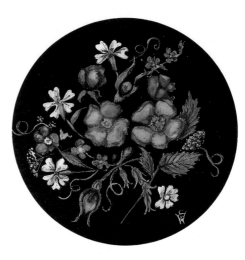

Stage 4

A circular wooden frame in light wood will suit this painting, or a plain mount with a square frame.

DEMONSTRATION

MORNING GLORY
(designers gouache on ivorine)

Gouache; periwinkle blue; lemon yellow and white
Brushes: sizes 000, 2, 3; ivorine 8 × 6 cm

This painting was by way of an experiment. I used the colours as I would watercolour.

I planned the drawing of the flowers directly on the surface by painting a thin outline in periwinkle blue. I then mixed the same colour to a fairly thick consistency and applied it quickly without reloading the brush. The colour overflowed a little into the flowers, but I was able to reshape them with a damp brush. I let it dry before lifting a little of the background back again into the flowers, so getting a lovely soft curve. Finally, I rebuilt the form with fine strokes in white gouache.

Mixing periwinkle blue and lemon yellow gave me the fresh green for the leaves, and, as with '*Summer Bouquet*' I removed a little paint at the edges, to capture a feeling of light. I had to be very careful not to disturb the smooth background.

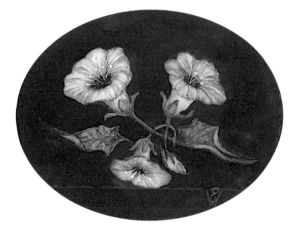

Finished painting

7
PAINTING ANIMALS

A love of animals and a lot of patience are needed if you wish to draw and paint them, especially in miniature. Experience of modelling clay and carving in wood will help you, and looking at china models can also be useful in thinking of animals in a three-dimensional way.

Always have your sketchbook (or camera) at the ready. Sketch quickly any pose that appeals – anything to try and capture the overall shape and structure of the animal or the expressive twitch of a tail or a liquid look of the eye. Keep notes of colouring. Study the animal's anatomy because knowing the bone structure will help you to paint the form as a whole. You can check details in good photographic reference books.

Various breeds call for different poses. Dogs of the pug-nosed variety need this accentuated by a full-fronted pose, whereas dogs with a long muzzle often look more graceful when painted in a three-quarters pose or profile. Portraits of the head alone are far easier than painting an animal in an awkward position. All animals look well when painted as if being 'shown', though if you do this you must make absolutely sure that the perspective is correct. Dogs and cats are obviously easier to draw and paint in repose rather than action. Cats look attractive asleep, curled up or when staring from a window in a reflective mood.

You will soon learn to select the most important lines of an animal. Charcoal and pastel can be invaluable mediums, as so much can be said in a few lines and the fuzzy edges of both quickly give an impression of fur. Use just a stroke of charcoal to indicate the top of the head, the shape of the muzzle, the slope of the neck. Position the eyes, and very important, the nose. A lot of work will be done later and the position of the nose aids the finer drawing. Your next step will be to scale down in pencil.

Experience in painting landscape and still life will help you place the animal in a suitable background, but in the first place, keep your miniatures simple enough to catch the character of the animal and the feeling of feather or fur.

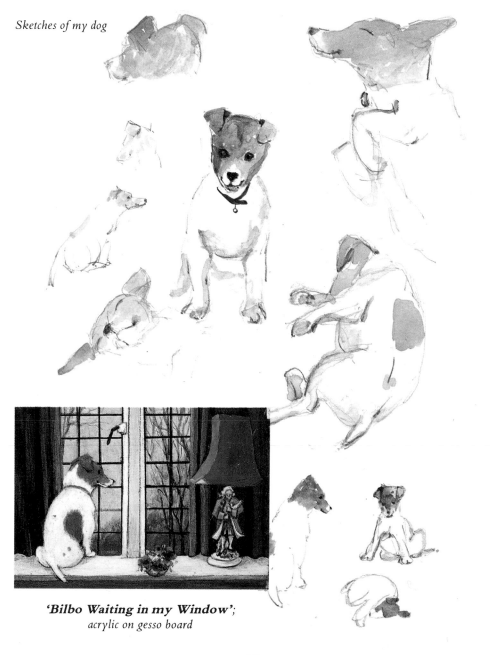

Sketches of my dog

'Bilbo Waiting in my Window';
acrylic on gesso board

feathers

jay *pheasant*

Painting feathers

If you are interested in painting birds, and they do make delightful miniatures, why not try and paint a single feather? Many feathers are already miniature in scale and you will find it invaluable to understand the construction. Note the direction of the shaft, and how the fine barbs grow upwards and outwards; the barbs are a mass of fine lines and should be painted as such. Remember that these lines curve slightly towards the tips. Of course, the shaft is not seen unless the bird is moulting but it will help you to feel the overall structure.

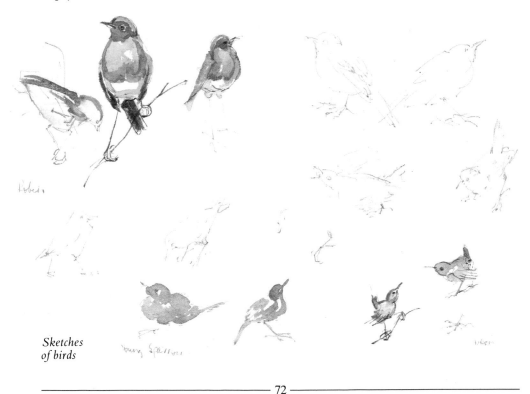

Sketches of birds

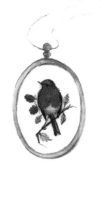

Colour drawing

'Humming Bird'
watercolour on ivorine

'Bobolink'
watercolour on ivorine

Painting fur

Before you start painting dogs and cats (or other animals) it might be a good idea to practise painting fur, just to get the feeling of how it looks and grows.

Start by looking for the darkest colour in the animal's coat, and suggest the form of this, the way it grows and moves. Lift out some of the edge so the tone weakens. Into this lighter edge, begin to stroke a darker colour. Place smaller dark strokes close in against the body. Then lengthen and strengthen the lighter tones.

Remember always to paint in the direction in which the fur is growing – that is, outwardly – and observe how it spreads in a fan-shape towards the edge. Finally, look for the brightest highlight and see if you can capture this.

Colours for fur

Grey fur I suggest you try light red and cobalt mixed with Paynes grey for darker tones, with cobalt and rose madder for the highlights.

Brown fur Burnt umber for the general colour, with the addition of Paynes grey for the darker tones. Try cadmium orange for the highlights.

Black fur I suggest Paynes grey for the darkest colour, with a little French ultramarine placed beside the short strokes, and rose madder added for the highlights.

Grey fur

light red

+ cobalt

makes grey.

Paynes grey for first strokes.

cobalt + rose madder
for second strokes.

Body shape with thin cobalt and
a little rose madder.

Black fur

Paynes grey

+ French ultramarine.

Stroke in cobalt blue.

Add more Paynes grey
+ rose madder.

White fur

Brown fur

Place burnt umber

Paynes grey

cadmium orange

side by side.

Add lemon yellow.

Otherwise leave surface free of colour
and stroke on white gouache.

DEMONSTRATION

MANDY THE KING CHARLES SPANIEL
(watercolour on vellum)

I knew this little dog well as she was a frequent visitor to my home. The owner had asked for a portrait of the dog to wear as a pendant. I wanted a good first sketch so I prepared all my working materials before she arrived. I set my drawing board up with cheap white drawing paper and had my pastels ready.

Sketches

Mandy always gave me a warm greeting and then ran excitedly round the garden with my own little dog. After a good game I was eager to start, and Mandy's owner soon put her through the exercise of 'Sit and stay'. I had to adjust my drawing board much lower, and sit on a low stool. The owner stood behind me, chocolate drops at the ready, and I worked quickly to find a few basic proportions, the top of the head, the length of the ears and the position of the nose. The dog was called for its reward and again put into position. Once more I managed to do a few quick strokes, again a reward for the dog, and so we progressed.

It is useless to tire a dog, so be content if you feel you have caught just the essence of the character. Later I scaled down the pastel drawing to the size of a pendant and so was prepared with a smaller sketch when Mandy came again.

Watercolours: light red, yellow ochre, burnt umber,
Paynes grey, cadmium orange, white gouache
Brushes: sizes ooo, 1, 2 and 3; vellum 8 × 7 cm;
Mandy's owner provided a pendant 5 × 4 cm

METHOD

STAGE 1 As soon as Mandy settled down I compared her with my larger sketch and corrected the proportions. I established a stronger drawing and made several colour notes. I noted that the eyes were very round, and the whiskers long and white. The highlight was bright, but at this stage I didn't register these fine details.

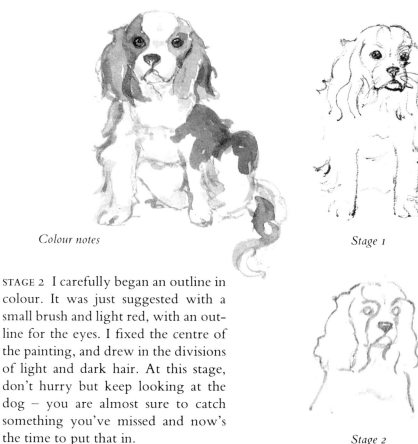

Colour notes

Stage 1

STAGE 2 I carefully began an outline in colour. It was just suggested with a small brush and light red, with an outline for the eyes. I fixed the centre of the painting, and drew in the divisions of light and dark hair. At this stage, don't hurry but keep looking at the dog – you are almost sure to catch something you've missed and now's the time to put that in.

Stage 2

STAGE 3 I mixed light red with a little cadmium orange for the first washes and applied the mixture with a size 3 brush. This fixed both the brightest and lightest areas in a golden tone. I checked up on the darkest part of the eyes, and also made sure I had the drawing correct. I indicated a few wiggles and knew I would remember the deep tones of the wavy fur of the ears, which was eventually painted in burnt umber and a little Paynes grey.

STAGE 4 A lot of the work on the miniature was done without Mandy being there – miniatures are like that. The concentration is such that you don't want to be looking at a moving model and you have to rely on your drawings and colour notes to a great extent. I used a rich mixture of light red and burnt umber and floated this over the length of the ears. With Paynes grey, I re-established the outline of the mouth and the line under the eyelids. The colour dries quickly on vellum and so I was able to enrich the colours with a small brush without disturbing the undercoats. I stroked in burnt umber for the really dark parts and also round the eyes. Thin Paynes grey was used for a small shadow under the mouth, and then I waited to see Mandy again.

For the final fixing of the highlight in the eye, I held a chocolate drop and got her really interested. I just had to remember that the brightest part came right across the curve of the eye. With a small brush and quite thick, white gouache, I put it carefully in place.

Stage 3 *Stage 4*

Taking the glass from the pendant, I placed it over the painting, and drew a faint line round the edge with a pencil. Vellum cuts easily with sharp scissors. If the glass fits the pendant the painting will also fit. Always make certain that the back of a pendant or any miniature is fitted securely in place.

CAT AMONGST THE CUSHIONS
(watercolour on vellum)

Vellum is a good surface to use for painting fur, though unlike ivorine it does not allow for colour to be lifted out constantly; it will only take this treatment once or twice, and then the surface will begin to roughen up and fine effects will be spoilt. Watercolour dries quickly on vellum and darker tones can be floated on to define shapes. Fine lines placed closely together will build up the effect of fur.

Watercolours: light red, cerulean blue, cobalt blue, rose madder, permanent rose, viridian, Payne's grey, white gouache
Brushes: sizes 000, 00, 1, 2, 3; vellum 10 × 8 cm; drawing paper; tracing paper; pencil; blue charcoal pencil or pastel pencil; oval or circular cardboard cut-out; water jar

Sketches of cats – take every opportunity to make them.

METHOD

STAGE 1 Sketch the cat and cushions on cartridge paper, keeping the outline clear and sharp. Decide on the shape of the finished work, though if you do want to change your mind later you can probably do so (I did with this painting).

Using the tracing method explained on p. 34, trace your initial drawing with a 6B pencil. Don't press too hard or indentations will show on the vellum.

STAGE 2 Now, gently, with an 000 brush and a mixture of cerulean blue and water, carefully outline the drawing, then taking a size 3 brush and the same mixture, float on the background. Bring this colour through to the foreground. Bear in mind now that the lace will have to be painted in white over the top of the background. Mix permanent rose for the cushions and using the size 3 brush shape up the cushions. Then mix light red and cobalt for the first wash on the cat, remembering to leave its white fur unpainted. You will now have established all your main shapes simply and broadly.

STAGE 3 This third stage requires concentration on the deeper tones of the cushion, and you also need to work on the fur and lace.

Stage 1 Sketch first, then decide on circular or oval frame.

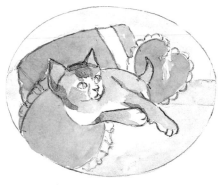

Stage 2 Float on main colour but leave the lightest areas.

First, add a little rose madder to a mixture of permanent rose and deepen the shadows on the cushions, curving your brush in the shape of the shadows. Begin to shape up the fur by mixing light red and cobalt with a size 2 brush. Paint the darker curves in the fur, leaving space between these. Let the area dry, then agitate your brush a little to blend the colour with the surface. You must be careful to observe the direction of the fur; now, using your finest brush and a mixture of Paynes grey with a little cobalt, paint in the hairs. Paint these a little apart, dropping your brush where the fur sprouts from the body and lifting it to a finer point towards the end of the stroke. Practice will help, but to be painted effectively, fur is rather slow work.

Next, with Paynes grey and an 000 brush, and the paint dry in the brush, darken the fur with tiny strokes but keep a certain distance as the tiny light spaces are effective.

Use a stronger mixture of rose madder and permanent rose and float this on to deepen the background; then make a thinner mixture by just adding water and float it on for the lighter foreground. Take care to place the colour well under the lace. Viridian is used for the eyes, with Paynes grey for the pupil.

Stage 3 Deepen background and cushion colours and go carefully when painting fur and lace.

Painting lace needs care – don't just guess at the design. Find a small length and have it before you; you will soon realize what strong shadows are thrown by the tiny threads. It can be helpful to sketch out a design much larger than the one needed in your miniature, so that you can paint the shapes and shadows convincingly.

Take white designers gouache and a small brush and make sure the base work is quite dry. Then begin to draw in the outline of the lace. Return and build it up further. Next, place a little of the dark mixture used for the background in between the curves and shapes of the threads, to bring the lace forwards.

Then, with a larger brush and a little cobalt blue, float some shadows in where the cushions curve.

How to paint the lace

Draw design in pencil and float on base colour. Build up design with white gouache and outline carefully where shadow is thrown.

Float thin white gouache on base colour. Allow to dry and draw on top with gouache. Note where light falls.

STAGE 4 Be careful now not to spoil the work, which is easily done in the final stages of working on vellum. Sit back and decide where a few strokes of dark colour can be stroked in to indicate the edge of the paws. Finish the design on the lace with tiny dots against the background. Work a little on the fur to establish the really dark form under the chin and at the tip of the tail. Place the highlight in the eye, remembering it should be curved. Finally, paint the whiskers. It is possible to sharpen up the white areas by painting in white gouache, but be careful if you do so, especially on the cat's face.

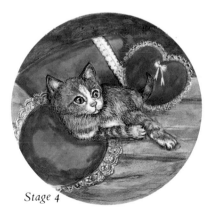

Stage 4

This miniature would look well in a circular or oval silver frame – or in a square wooden frame with a plain circular mount, perhaps with a tint of silver.

Little kitten on copper

I had read about some miniaturists painting on copper and a small oval piece of it came into my hands. I experimented and found that oil paint took easily on the surface. I was careful to make a good working drawing first, and to find the right colours.

Kitten
oil on copper

Look at the examples of painting animals in chapter 2 for further hints on the subject.

8
PAINTING PORTRAITS

Portraits in general

It will be of considerable benefit if you have painted portraits of a conventional size. Ease your way into miniature portraits, using all your knowledge about working to larger scales. There are many books on the general principles of portraiture, all of which apply to the miniature too. Don't start the miniature portrait in a rush – careful draughtsmanship is essential in the early stages, when you must get the problems of proportion, pose and clothing right.

It is very helpful to have a friend or member of the family to sketch – to begin with you needn't attempt a likeness, but go for correct proportions, and a likeness will follow with correct drawing. Concentrate hard, and study the faces of your family, friends and people on television. Keep all your drawings as a record. Small children have short necks, and the neck lengthens in adults; in old age it shortens again and you may find it fascinating to paint the lines in sagging flesh. One of the intriguing aspects of portraiture can be the family likeness that emerges even across a large age gap – in a grandmother and grandchild, perhaps.

A likeness is an elusive thing. The subject is often not the best judge of his or her own portrait, because we don't see ourselves as others do. We glance quickly at ourselves in the mirror, and will probably have a bland expression on our face at the time. This expression changes the second we become animated, and capturing an element of animation is vital for a lively portrait. A portrait should be a truthful interpretation, which, given good draughtsmanship and sensitive paint handling, it will be. A little flattery may be allowed if the subject has a full chin – it can be disguised with subtle shadows or a thoughtfully placed scarf.

Clothing should be kept in character – a sportsman in an open-necked shirt, a retired executive in a well-tailored suit and a neat tie. Jewellery can be important, and requires careful painting.

Often a portrait will be successful everywhere but for the mouth. Lips are very expressive and in repose can give a wrong impression of character. How often have

you sat opposite someone and thought they looked miserable, only to find how different is their expression once they smile? But a portrait shouldn't portray a broad smile. The mouth can be slightly open, and the corners lifted on the verge of a smile. The subject wants to appear as though in conversation with the artist, so that he or she will communicate with anyone looking at the portrait.

Painting miniature portraits is a real challenge. To begin with, study proportions and shapes. The overall size of the head, including the hair, must not be larger than 5 cm. A comfortable size, particularly in the beginning, is approximately 4 cm. But you will soon discover a size which suits you and probably develop a preference for a particular pose.

Before you start, some general observations on colours may be useful. Always have some practice in colour mixing on your chosen surface before you start properly.

Skin tones

I prefer light red, and for a child add a little vermilion. Highlights can be simply the white surface left to show through, if you wish. I tend to use burnt umber for darker complexions, modified with yellows. Each subject needs to be studied for skin tone.

The mouth

This is very rarely a bright red, but is usually a richer, pinky tone of the complexion. Again, I like to use light red. Small children often have a moist-looking mouth.

The eyes

All the blues can be modified well, and for a blue-grey I like light red and cobalt. The pupil doesn't want to be black; Paynes grey with a little French ultramarine is effective.

Hair

Here are some suggested colour combinations for hair, and tips on how to convey shape and movement. Hair is never absolutely straight unless it has been lacquered for some theatrical effect. It follows the shape of the crown as it falls towards the ears and shoulders, and by using both hard and soft pencils and practising a few simple shapes, painting it will be that much easier. Always note the parting and how the hair grows away from it. Start your drawing in the direction that the hair grows and try to suggest its movement in simple single lines. Gradually build up the strokes.

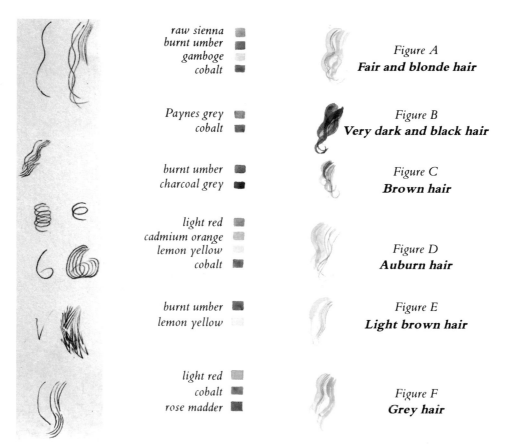

raw sienna
burnt umber
gamboge
cobalt

Figure A
Fair and blonde hair

Paynes grey
cobalt

Figure B
Very dark and black hair

burnt umber
charcoal grey

Figure C
Brown hair

light red
cadmium orange
lemon yellow
cobalt

Figure D
Auburn hair

burnt umber
lemon yellow

Figure E
Light brown hair

light red
cobalt
rose madder

Figure F
Grey hair

All the colours suggested above are fine with watercolour, oils, gouache and alkyds; the illustrations provided are in watercolour.

Fair and blonde hair Try raw sienna, burnt umber, gamboge and cobalt blue. First establish an outline with a thin mixture of raw sienna, and float a wash over the whole area in the same tone. When dry, begin to draw in fine lines of burnt umber to indicate folds and edges. Drop in a little gamboge for the highlights. Depending on the colour of the background and clothing, a hint of blue or purple may be needed in the deeper tones. A blue shadow may be thrown up against the side of the face and across the forehead, so we could finish with a fine line of cobalt blue as the portrait nears completion.

Very dark or black hair Try charcoal or Paynes grey and cobalt blue. Dark hair is very rarely a stark black, though it may appear to have a dark blue sheen to it. Begin by painting the lightest tone, or the part showing the most shine; try a deep blue-grey wash of charcoal grey and cobalt blue. When this is dry, and remembering to follow the fall of the strands, stroke in the deeper tones with a small dry brush. Drop in a little cobalt to sharpen the brightest area.

Brown hair Try burnt umber and charcoal grey. There are many colours which can be called brown: light, medium and golden brown, red and dark brown, and even 'mouse'. A good general colour scheme is burnt umber and charcoal grey, to which you can then add a variety of tones. Light red and one of the blues, and even a hint of viridian will give a bright 'lift' to a rather dull colour. Make the most of the highlights – careful drawing of the fall of the hair is needed to do so. Begin with a basic wash all over of burnt umber and when this is dry put a thin wash of charcoal grey into the darker folds. Then, mixing the two colours together on your palette begin to stroke in the fall of the hair, looking carefully at the clothing which comes next to the face. Pick some of this colour up and drop in tiny strokes of it into the hair. It's surprising how harmonious this will be. Light brown hair needs to be kept soft, so if you use only two colours it won't get over-dark. Apply a thin wash of burnt umber well over the whole area and when dry, float lemon yellow over it, leaving some of the brown to show through. Then deepen the final strokes with a dry brush and fine strokes in burnt umber.

Auburn hair Try light red, cadmium orange and lemon yellow. Look for the lightest and brightest tones first – usually these will be golden. Apply a weak wash of light red to begin with, and when this is dry float over a cadmium orange wash. These two colours, blended on your palette, can be used for suggesting the movement of the hair, waves or curls. Try not to allow your paint to get too heavy or dark in the shadows – a delicate, light touch is needed. Lemon yellow is useful for adding a final little highlight, just flicking it over the curves.

Grey hair Try light red, cobalt blue and rose madder. You may need some white when using alkyds and oils. Grey hair is a delight to paint, but be a little cautious if a lady has had a colour rinse applied as it will give a much deeper and more definite blue to the shadows. A little rose madder will help here. Begin with a mixture of light red and cobalt, being careful to follow the flow of the hair or, in a close-

cropped gentleman, the shape of the head. With a light mixture of cobalt, establish the deeper tones. Let it dry and then decide exactly where the dark lines should be placed. A lavender shade made with rose madder and cobalt helps a lot and depending on the background a little white gouache can be used with great care, in the shape of the highlight. Usually grey hair calls for a darkish overall background and a little white outlined against the head will bring its shape well forward.

Drawing basic proportions

Have your model sitting opposite you in a window. At this stage you aren't going to attempt a likeness, just get the right proportion and shapes. Ask your model to sit upright and seat yourself at eye level to him or her. Work in daylight, as artificial lighting may throw complicated shadows across the features.

6H and 2B pencils; ruler; drawing pad; oval cut-out with aperture 9 × 7 cm; eraser

METHOD

Draw an oval approximately 9 × 7 cm. The head should be not too high and not too low. Divide this oval in half by using a ruler, using the half-line as the base for the chin, which will position it well in the oval. The length of the head, without the hair, will be 3.5 cm; mark the top of the head. Draw an oval between the top and bottom lines, approximately 3.5 × 2 cm.

Stage 1

*Draw an oval
approximately
9 × 7 cm.*

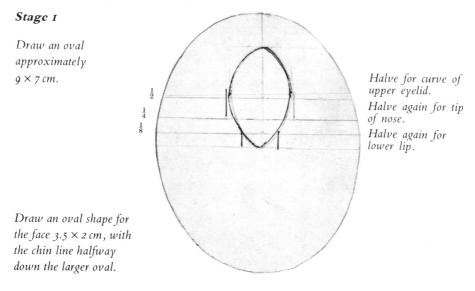

*Halve for curve of
upper eyelid.*

*Halve again for tip
of nose.*

*Halve again for
lower lip.*

*Draw an oval shape for
the face 3.5 × 2 cm, with
the chin line halfway
down the larger oval.*

Carefully divide this oval in half with your ruler, then halve it again; then halve this lower portion. The ovoid shape for the face has now been divided up into sections of $\frac{1}{2}$, $\frac{1}{4}$ and $\frac{1}{8}$ depth. Now begin to look closely at your model. Place a small curve just above the halfway mark for the upper eyelid. Then place in the tip of the nose, and between the tip of the nose and the chinline, mark in the lower lip. Notice where the ears come. Erase your marks and start again if you feel the drawing is not correct.

Stage 2

Begin to establish the features.

Draw in eyebrow and iris.

Draw in ear and nostrils.

Draw line where lips meet and upper lip.

Sketch in hair.

Neckline will curve towards shoulders.

Draw a line from each iris to tip of nose. This will help to establish proportions.

Draw a 'plumb line' from inner corner of each eye to find position of nostrils.

Draw a 'plumb line' from inner side of each iris to find position of mouth.

You now have a basic face and must begin to modify it to represent an individual.

Stage 3

What can make basic proportion look more individual?

1 The eyebrow is not a curve but more an inverted V shape.
2 The nostrils are no longer two dots but have definite shape.
3 The mouth has a curve and a lift at the corners.
4 The chin is rounded.
5 The hairline is wavy and falls forward over the brow.
6 The collar line establishes length of neck and slope of shoulders.

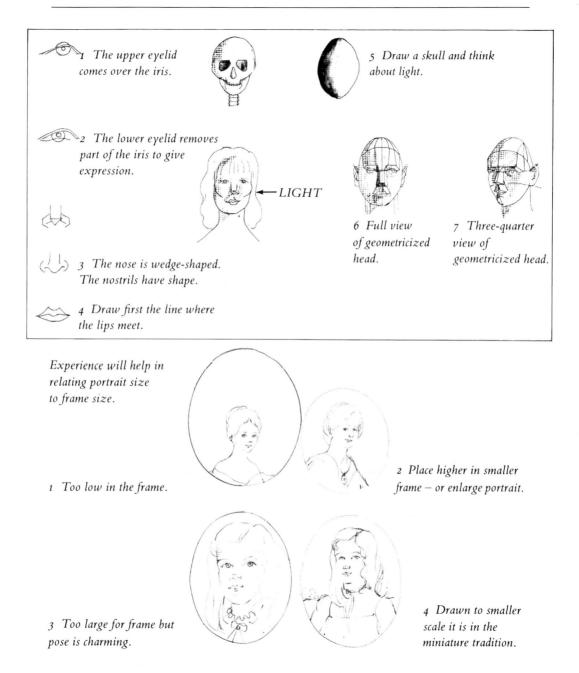

1 The upper eyelid comes over the iris.

2 The lower eyelid removes part of the iris to give expression.

3 The nose is wedge-shaped. The nostrils have shape.

4 Draw first the line where the lips meet.

5 Draw a skull and think about light.

← LIGHT

6 Full view of geometricized head.

7 Three-quarter view of geometricized head.

Experience will help in relating portrait size to frame size.

1 Too low in the frame.

2 Place higher in smaller frame – or enlarge portrait.

3 Too large for frame but pose is charming.

4 Drawn to smaller scale it is in the miniature tradition.

DEMONSTRATION

A FIRST PORTRAIT
(watercolour on ivorine)

Using the basic proportions you have just drawn, and the materials listed below, you can now follow through a method which I find works very well. It requires a good basic drawing and simple washes, and will help you come to terms with shapes, shadows and the surface you've chosen to work with. I have restricted the number of colours, so your mixing is simplified. There is no stippling and no hatching involved, but you may probably want to experiment with these at some time when painting portraits. Always bear in mind that you will extract what you want to when following these demonstrations, and adapt it to your own style – that's the whole idea. You may like to re-read the section on ivorine and water-colour in chapter 1.

> *Watercolours: cobalt blue, cerulean blue, light red, lemon yellow, burnt umber, Paynes grey, vermilion, rose madder*
> *Brushes: size 000, 1, 2, 3; water; pencils; rag; eraser; paper; ivorine, size 9 × 7 cm; oval aperture or frame, 8 × 6 cm*

METHOD

STAGE 1 Prepare your ivorine by washing and rubbing lightly with sand paper. It must be grease free. Place the drawing underneath the ivorine and stick it down at the top. With an 000 brush and a thin mixture of cobalt, paint the outline of the drawing, taking care that the width of your brush has not allowed the drawing to become too large; if it does, you have pressed down too heavily. Don't let the blue outline become too dense. If you aren't satisfied, wash off the outline and start again, until you get it right. You will be learning all the time, so don't get discouraged.

STAGE 2 Now, mix light red into a water mixture and use a size 3 brush; load it carefully and apply a wash over the whole of the facial area. While it is still wet, lift out some of the highlights, down the nose, the forehead and chin. Try and keep the eye socket clear of any colour. Mix cobalt with a little light red, and place it in the iris. Note how the upper part of the iris actually disappears behind the top of the eyelid; think of it as a blue circle, where only a portion of it is visible. With light red and the 000 brush, draw in the nostrils and strengthen the chinline.

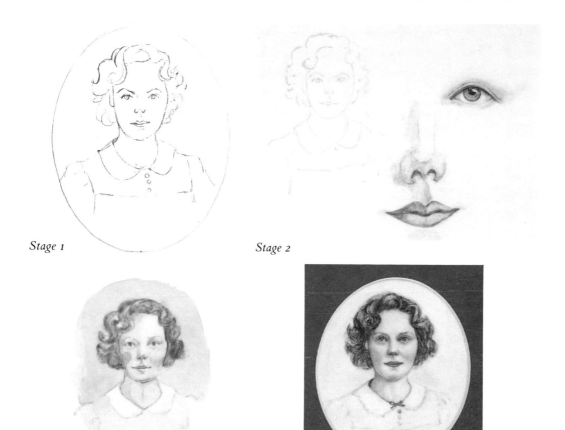

Stage 1

Stage 2

Stage 3

Stage 4

STAGE 3 Work on your portrait all over, consistently. Never complete one part too soon, as this could put the balance of colours out. Try out your brushes on the mouth; you will certainly need to use the size 1. Mix vermilion rather thinly, then darken the inner line with rose madder.

Vermilion and a size 2 brush will be useful for dropping a round blob of colour into the cheeks. Let this dry, then with a size 3 brush, clean, water-filled and containing no colour, float the remaining water spreading the colour over the cheeks, so that the vermilion will merge with the light red. Don't forget the background. Cobalt and a little lemon yellow and your largest brush will make a good

tone and give a feeling of sky. Sketch in the clothing. Mix burnt umber for the hair and apply in the shape the hair falls.

STAGE 4 Your little portrait will now need what I call 'refining'. This means using your smallest brush, darker paint and looking for the shadows. A deeper mixture of light red is placed gently down the side of the nose and round the chin; use this colour, a fraction deeper, for the neck. Next comes an extra wash for the hair in burnt umber, and it will almost be finished. Just define the edges. Use rose madder for under the upper eyelids, Paynes grey for the pupils and a fresh outline in cobalt. Rose madder is used for the tiny bow in my picture. Put a little cobalt into the corners of the eyes, which makes them appear round.

Lemon yellow and cerulean are used here for the simple shaping of the dress. Then let your painting rest for a few days, taking a look at it now and again. Hold it up against the mirror and see it in reverse – errors can sometimes more easily be seen this way. Be prepared to wash it all off and start again if you aren't satisfied! Ivorine is very encouraging and comes back smiling however often you wash off a painting.

The self-portrait

To paint a self-portrait may seem rather a conceited thing to do, but it is, in fact, just the opposite. Rather than putting friends and family through the trials of posing, you impose this discipline on yourself. By studying your own face, you can find the answer to many problems, seeing how the eyelid curves, how the eyebrows grow on the edge of the eye socket, that the lips have many colours. You may like to have a photograph taken of yourself to use as an aid but there is nothing to match looking closely, getting the drawing correct and painting the miniature while continuing to look at yourself in a mirror.

Begin by standing up in front of a long mirror and finding a position you feel you will be able to hold while drawing and using your paint brushes. In my case, I stood sideways and then turned my head to a three-quarter view. I knew I could sit on my typist's swivel chair and keep looking easily into a smaller mirror. If you have been used to working in charcoal, you may like to use this for preliminary sketches, and scale these down.

Smiling portraits are always a little more difficult, so I decided just to try and look pleasant. The mouth does tend to droop a bit when you are concentrating or in repose, you may need to compensate for this.

DEMONSTRATION

THE SELF-PORTRAIT
(watercolour on ivorine)

*Watercolours: cerulean blue, light red, burnt umber, lemon yellow,
Paynes grey, vermilion, cadmium orange, raw sienna, rose madder; cobalt
Brushes: sizes 000, 1, 2, 3; piece ivorine 8 × 6.5 cm; oval cut-out; water;
blotting paper; drawing paper; pencil; eraser*

METHOD

STAGE 1 Settle yourself comfortably and have the mirror angled conveniently. I did
not have my mirror directly in front but placed it to the left. I also had a hand mirror
for close observation.

 With an HB pencil I began to draw the eyes, first the upper lid, then the iris. I
worked outwards to the hairline and cheeks. I turned up my collar a bit to give a
nice shape to the blouse. I kept the outline rather sketchy until I was sure of it, then I
strengthened it, so that I could be certain to see it through the ivorine.

STAGE 2 Having prepared the ivorine by rubbing it with fine sand paper, I attached
it over my drawing. Using cobalt blue and my 000 brush I traced through a thin
outline. I checked up constantly on my proportions and I found the oval aperture
helped to get the portrait correctly in position, not too high and not too low.

 I decided to treat the next stage with thin washes of light red for the complexion,
and burnt umber and lemon yellow for the hair. I used a feather-like touch while
floating this mixture on, and didn't disturb the pale blue outline. I darkened the
eyes, and began to stroke raw sienna in with my small brush to darken the hair.
Cerulean blue and light red made a soft grey for the first wash over the shoulders. A
thin mixture of vermilion was then placed over the cheeks. It dried with a darker
line at the edge, so, using a size 2 brush, filled only with water, I gently stroked this
edge away.

STAGE 3 Now a decision had to be made about the background. I thought blue
would bring out the colour in my hair and so mixed rose madder with cerulean blue
·and placed this along the shoulderline and up towards the hair.

STAGE 4 The final stage always calls for more caution. A lot of the work is done with
smaller brushes and with the paint a little thicker and darker. I put lemon yellow

Stage 1

Stage 2

Stage 3

Stage 4

and Paynes grey into the darkest part of the hair, with a blue line to indicate the slight shadow thrown by the hairline across the brow. The eyelids needed lightening and more tone to be placed behind them. Mixing cobalt and rose madder together makes a nice soft lavender which looks good with a fair complexion. I was careful to outline the nostrils with light red and paint the mouth with vermilion.

Finally, I had to take a long repeated look in the hand mirror to decide where the lips met, and what sort of line they made. With rose madder and a 000 brush, I drew the line life-size on a piece of paper before placing it correctly on the miniature. A hint of the lavender tone was used for the corner of the mouth. A few more strokes of cadmium orange were used to place highlights in the hair.

Finally I placed a blue wash thinly over all the background and sponged and stippled with a mixture of cerulean and rose madder. The little pendant I usually wear added more interest to my plain blouse.

Using the glass from an oval frame as a guide, I cut the ivorine and placed it behind convex glass. Into the back I put a small lock of my hair, along with name and date – who knows, maybe the portrait will become an heirloom!

Painting a member of the family

DEMONSTRATION

ROBERT IN COSTUME
(watercolour on ivory)

If you have an interest in history and would like to recapture something of the past, why not paint a member of your family in costume?

My son took some persuading, but I hired an 18th-century jacket and wig, and I knew the exercise would be full of fun when he first put these on. But both wig and jacket were rather uncomfortable, and my family are always short of time, so I knew the serious expression I wanted would take some finding.

There are lots of books about old miniatures, and you could always find a costume and wig there, and then try to place a friend or relation in the portrait. When you are learning portraiture, though, there is nothing so challenging as having the model sitting for you, so do try for this.

Seat your model comfortably – you could even bring the television into your working area. You will have to keep interrupting the programme to ask your model for a lively expression. It may help to sit on a low stool, a little to one side. Sketch as quickly as you can and don't worry too much about the size – you can scale down later. Just get the proportions, the angle of the collar, the slope of the shoulders. Think of the face as a map, following the angles round corners, up and down, across and outwards.

I prefer to mark the top of the head, then the chin, then place the eyes. I then look for the shape of the jaw and see how it is positioned against the clothing – in this case, the collar. The chin had a firm shape and helped me to place the hairline. The stiff collar partly hid the face, so I had to lower it.

Later, without my son sitting for me, I scaled down my over-large but very quick sketch and decided to place it in an oval frame 7 × 5.5 cm. I reworked the pencil drawing to get a good outline.

Watercolours: light red, cobalt blue, cerulean blue;
vermilion, lemon yellow, Paynes grey; rose madder
Brushes: sizes 000, 00, 1, 2, 3; piece ivory or ivorine, 8 × 7 cm;
water; rag; pencil; paper

METHOD

STAGE 1 I asked my son to wear the costume again so I could check up on the fall of the lapels, and draw in the silk cravat. I checked up on the drawing and decided where the curls were to come and also where the bow broke the line of the collar. I made colour notes for the next stage.

STAGE 2 I then traced through the drawing in blue onto my piece of ivory, checking it against the first larger-scale drawing.

Stage 1

Stage 2

Stage 3

STAGE 3 This stage was important, as I was beginning to work in colour and hadn't got my son with me. A lot of work on a portrait miniature may have to be done without your subject being there, so your colour notes are vital. I followed through my working method, applying thin, light red washes for the complexion, cobalt and light red for the wig and jacket trim, and a first wash of vermilion for the jacket. Paynes grey and lemon yellow were used for a thin wash all over the background. The wash overflowed into the hairline, but this didn't matter as I was able to pick it out with a dry brush and so re-establish any lost effect. Then I spent time on the eyes, nose and mouth.

STAGE 4 I had to wait some time before I could finalize this little portrait, and it was a temptation to fiddle about too much in an effort to try and find a likeness. However, it is always best to wait patiently until you can check up. The correct placing of the shadows will help you towards that elusive thing, the likeness. I knew it was almost there, but needed a little careful drawing in the right colour in the right place.

Stage 4

A second coat of vermilion was floated on over the first thin coat. This is very tricky, and it takes practice. Take your largest brush and load it with colour; just think of the water passing from the tip of your brush to rest on the surface, and that you are moving the colour from one side to the other. It won't matter if you over-flow into the background or the lapel, as you can correct all that with a clean but fairly dry brush.

I painted some form on the reverse side of the ivory (see previous hints on p. 38) and because the colour was very much stronger than the natural colour of the face (in fact, a deep rose madder) it was visible in a subdued tone through the surface. A round blob of vermilion was placed and then reshaped for the cheeks. Then I floated on a thin wash of lemon yellow to give a glow to the complexion. The shadow under the chin was important, as it separated the shape of the jaw from the cravat – a lavender blue did very well. This tone also went into the wig. Then the buttons were painted and finally a little hatching over one side established a deeper shadow behind the figure.

With patience and cooperation I captured really quite a good likeness. The piece was fixed into a dark wooden frame, with a gilt oval insert.

Portraits from photographs

Many portraits are painted from photographs alone, without the artist ever seeing the subject. Photographs are really excellent guides, and if you feel you can make a faithful 'copy' from one it does give a wonderful sense of security. However, as an artist you will want to feel that you've put the character into a portrait and if possible your miniature wants to look as though a photograph hasn't been used at all. See if you can get hold of a number of photographs of the subject, and study them all carefully. But do bear in mind that it's dangerous to take a feature from one photograph and fit it into another. (Beware also of the wide smile.) Select one photograph as a working model, and then put aside the others so they can't distract you.

The usual methods of scaling down can be used; if you are very fortunate the photograph may already be to the right scale and you can take a short cut by tracing it. Be careful, though, not to leave an indentation on the photograph by pressing too hard with a pencil.

Sepia photographs taken before the invention of modern lighting techniques

have a lovely soft quality to them, with the dress and background often merging. A family photograph, taken a hundred years ago can be turned into an attractive miniature. The background may be done with one simple wash, toning in with the clothing, and the features painted in delicate tones. The whole effect may be really very attractive.

As I was working my way through painting my family in miniature, I wanted to include as many of the past generation as I could. When an old sepia photograph of my mother-in-law was given to me I knew it would make a pleasing study. The hair was worn in a big bun, she had tiny gold spectacles and wore full sleeves and a diamond brooch – all attractive and distinctive touches.

I also painted my mother. I had to use a photograph for the pendant-sized miniature of her when she was a young woman. Later she patiently sat for the other miniature. Both these portraits were exhibited in the Royal Academy Summer Exhibitions in London.

Portraiture from a photograph

The artist's mother aged 83

Miss Joel

The artist's mother as a young woman

DEMONSTRATION

THE OLD SOLDIER
(oils on vellum)

This portrait was originally painted to a size of *c.* 51 × 41 cm, in oil on canvas; I scaled it down. The dignity and pride expressed in the lovely old face held great appeal for me. His jacket seemed over-large, and the manner in which it hung from the shoulders suggested something of the frailty of old age. I wanted the hands to be included, and I felt that the slant of the cane held the composition together. (Never be afraid of painting hands – they require good observation and drawing, but they are so effective in suggesting character.) I also studied the angle of the legs and the space outside them (the negative shapes) to help me find the correct width.

Oil colours: titanium white, light red, vermilion, yellow ochre, chrome yellow, cobalt, rose madder, burnt sienna, black
Drawing paper and pencil; turpentine; rags; brushes: sizes 0 and 1;
vellum 10 × 7.5 cm; small wooden frame with aperture, 8 × 6 cm

METHOD

STAGES 1 and 2 I made a good pencil sketch, deciding on the correct composition. Using a small brush and a thin mixture of cobalt blue I transferred the initial drawing onto the vellum. I let this dry. Titanium white with a little light red and yellow ochre was then mixed to get a warmish flesh tone and this was applied all over the features and hands.

The vermilion coat was blocked in, as were the hat and trousers in black. I made a decision at this stage about the background colours, choosing thin ochre and a mixture of cobalt and chrome yellow. I filled this in to see the effect of the vermilion against the other tones. I intended to introduce a speck of all the colours used in the medals, to bring together the tones. I discovered just how important were the various shapes made by the jacket cuffs, the curve of the braiding and the straight edges of the wooden seat behind. I let the first coat dry well. The painting was now all down in plain blocks of colour. (If you are following this demonstration now is the time to check on the overall shapes, consider negative shapes and correct the drawing, if necessary.)

STAGE 3 When the painting was dry, I began to work in small strokes, applying the paint quickly. For the cheek I added rose madder to cobalt blue, bearing in mind the

formation of the skull. The same tone was used for the shadow beneath the hat, the space where the hands disappear into the sleeves and where the fingers fold away from the light. I placed the eyes in with cobalt. I used orangey tones for the highlights on the cheeks and nose, and the backs of the hands. I let the paint dry well, and then placed the glasses correctly and painted in the detail of the medals. White was used for the moustache and the buttons. The edge of the spectacles was drawn in and tiny highlights placed in the eyes. The jacket still needed some form to it, so folds were painted in.

The portrait was framed in wood, with a narrow strip of gilt inset.

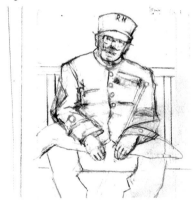

Stage 1

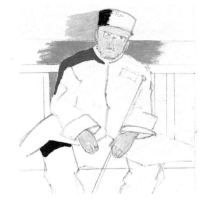

Stage 2

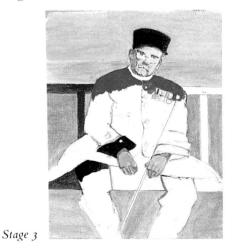

Stage 3

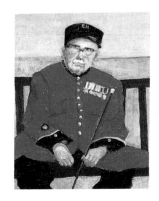

Stage 4

9
PAINTING CHILDREN

If you have children or grandchildren of your own, you have a real advantage over the miniaturist who does not, for you will have the opportunity to observe and draw children when they are quite unconscious of your purpose. Children make enchanting models but are easily embarrassed by scrutiny, and you will have to earn their cooperation and become their friend if you want to draw and paint them. You will need plenty of patience too, or their restlessness will prove aggravating. Rapid movements make the subject difficult to capture, and the head can tilt at innumerable angles. Yet to paint children well, good draughtsmanship is essential. This is where the photograph is invaluable and most miniaturists like to work both by drawing from life and using photographs as an aid.

First, find a congenial and convenient model. You don't want to work against the clock – take your time. Start with quick sketches of charcoal on paper; you need to study shapes and shadows and get them down broadly. Charcoal is a splendid medium as the edges can be smudged to suggest form. Try to capture the essence of the character. Follow your sketches with a line drawing in pencil to the scale of your miniature. Make plenty of colour notes about hair, eyes and complexion.

Five to seven years old is a lovely age group to paint, when children have often lost their shyness and will readily hold a conversation. You are looking for that vital something which makes a particular child quite different from another.

Some children are easily bored and it is certainly difficult for them to sit still for long; they are full of energy and you must supply toys and equipment to keep them interested. I have a selection of construction toys, crayons, colouring books and puzzles for the younger child. I put these on a low table and take my first sketches from across the room, just asking the child, now and again, to look towards me. I can get a quick basic sketch, find the proportions, note the colouring and talk to the child – perhaps stopping to help with the puzzle, if necessary – anything to humour the child!

It can be very helpful if friends bring along a child to model for you, as you can

enlist their help. Get the parents to blow bubbles while you take photographs, and later, to read to the child while you are concentrating on tighter drawing.

When getting your first drawings, look at the size of the eyes in relation to the width of the nose. The mouth is usually very small, and nearly always open. Take your proportion from the actual width of the eyes; think of a small triangle taking you to the tip of the nose, then divide the space between this tip and the chin to find the mouth. Keep your drawing very basic – the likeness will arrive when the drawing is correct.

When working directly from a photograph, there are several things it is as well to avoid. One is the big wide grin – full of fun, but full of difficulties for you. Teeth must be just suggested if the child holds the mouth open naturally, and it is far better to understate, rather than over-paint a mouth, whatever the age group. Often a school photograph, when the clothing is all lopsided and the hair untidy, will have unsophisticated direct lighting that will help you. Clothing and hair can easily be tidied up in the portrait. Be wary of the photograph which is too dark or has a child looking sideways. Unless you are able to study the child personally, you won't get a good enough drawing from this angle.

Usually, one plain colour or a blue sky will suffice for the background, and inclusion of a child's favourite toy (or even the family pet if this doesn't add too much to your problems!) in the painting, will evoke all sorts of memories in years to come.

DEMONSTRATION

OLIVER
(watercolour on ivory)

This little boy was just four years old when we first met, and was not over-keen on being painted. I thought he would make a charming subject for a miniature portrait, and I soon had his parents' consent to resort to bribery to get results. I gave him an old broken alarm clock to take apart. Small children are often curious to know what goes on inside such things, and he settled down happily with the smallest screwdriver I could find to see if he could make the clock tick.

I set up my sketchbook two metres away from him and he was so captivated by what he was doing that my own work went quite unnoticed. I kept my eye on what his fingers were doing and provided small lids to put cogs and springs in. I also asked

him to keep looking up at me so that I could get down my initial drawing. I decided to draw his head and neck to a depth of 4 cm, placing two pencil marks 4 cm apart and then looking for the main proportions and features between these two marks. I drew the eyes first, about halfway between the pencil marks, then put in the cute tilt to the tiny nose. The chin was then placed on the lower pencil line. The hair fell about in an untidy mop, so I quickly sketched it in.

I asked Oliver to look at me while I counted to ten. He was loath to stop his investigations but I promised him an old electric iron, and he gave me a very direct look which I somehow captured. We have to accept that there is an element of luck in making the right pencil statement with a delicate area such as the mouth, and I only hoped that I could transfer this determined look successfully when I came to work in colour.

When Oliver came again, we had established a great friendship. I told him the iron wasn't working, and asked if he could oblige . . . I set up my paints, and began to work in colour, with very slow counts to ten whenever I wanted Oliver to look at me directly.

Watercolours: cobalt blue; light red, Paynes grey, burnt umber, vermilion, rose madder, cadmium orange
A piece of leaf ivory 9 × 7 cm (ivorine would be fine too); brushes: size 000, 1, 2, 3; white saucer; water; rags; paper and pencil; aperture 9 × 7 cm

METHOD

STAGE 1 On Oliver's second visit I checked that the pencil sketch was drawn to the correct proportions. I had a very sketchy likeness. Children of this age do have large heads and the mass of hair made Oliver's head seem even bigger. The shoulders were small, and I decided to give some fullness to the top of the sleeve. I made a note about this, and also decided to include a little more detail down the shirt front.

STAGE 2 I traced the drawing in thin cobalt blue, being very careful that the lines weren't too thick. If so, the proportions can soon be lost and the miniature suddenly becomes too big; it is the thickness of the stroke that makes the difference.

STAGE 3 I mixed a wash of light red and applied this over the whole face with a size 3 brush. It didn't disturb the underdrawing in blue – in fact, by just removing a very slight amount of paint, this blue edge floats into the skin tone and registers the beginning of the form on the turn of the cheek. Burnt umber with a little cobalt to

take away some of the strength of the brown was then mixed and washed over the hair, to indicate its lightest part, and while the paint was still damp I put in a stroke of light red. The eyes were drawn with a small brush and I made sure they were actually looking at me. Quite a lot of the iris disappeared under the upper lid – remember always to draw in the whole iris as a circle, then remove a bit from the top and bottom of the circle. The slight lift of the chubby cheek makes this necessary.

I mixed cobalt and rose madder together for the shadows over the eyelids and under the chin. I applied a further wash of burnt umber for the hair. Remember the smaller the area being painted, the smaller the brush required.

I settled for a simple sky background in cobalt, so put this on, dropping in a hint of rose madder to one side. The shirt came next – again a simple wash with a size 3 brush, and the grey-blue tones of light red and cobalt. I needed to see Oliver again to check on the colours.

STAGE 4 Some blue was needed to improve the painting of the eyeball. I took a small brush to do the refining, and went carefully. I used a deeper mixture of light red for the shadow under the nose and vermilion for the lips. The strong line of the mouth I had made in my preliminary drawing now paid dividends – I could place it confidently, in rose madder. It always helps to have a little practice in a colour on the edge of your work before making a very delicate stroke to get the angle of the brush and the delicate, feather-like touch right. Don't forget that ears are quite dark on the inside, and the neck needs emphasizing against the collar. Again, I used fine strokes with a small brush. The upper eyelid was finally darkened with a stroke of rose madder, which blended with the blue already placed. When painting miniatures we don't always mix the colours on the palette, but place them on top of one another to achieve the desired effect. I carefully painted in the cheeks, using vermilion.

I deepened the vermilion on the upper lip and picked out the shape of the highlight on the lower lip. I was careful with the shape, so that I didn't disturb the vital centre line.

Then I retrimmed the outline of the frilly shirt and placed in some grey-blue shadows to suggest the tiny body inside. The arms came into the miniature at a slight angle. The hair needed darkening so a broad wash of burnt umber with cobalt was added, painted on in the shape the hair fell. I included a little hint of green at the base of the portrait, mixed from cobalt and cadmium orange to give a feeling of the

open air. I also used cobalt for the little bow. No stippling or hatching was used in this portrait, just simple washes and carefully drawn fine outlines. It was exhibited in the Royal Academy Summer Exhibition.

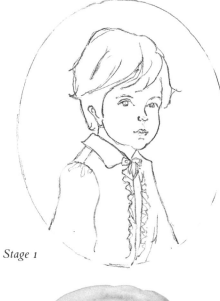

Stage 1

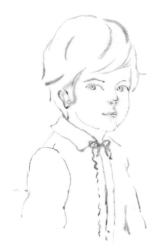

Stage 2

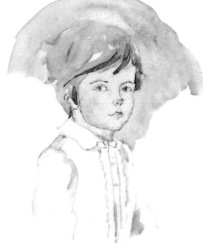

Stage 3

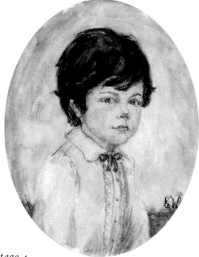

Stage 4

DEMONSTRATION

ANNA, LUCY AND HOLLY
(watercolour on ivorine)

Posing three members of one family is rather like having three flowers to arrange —
it is easier than having two flowers! The children were all of a different height and
colouring and were quite different in character, and presented me with a great
challenge.

I asked them just to stand in front of me and arranged them according to height.
The little one in the centre soon had the protective arms of her elder sisters round
her shoulders, and she asked for her doll to be included. There was also harmony
about their clothing, for each was wearing blue, and looked natural and unfussy. I
made my first drawing out in the open air, as I felt the detail in the clothing would
look right against a sky background and also some foliage against the red collar
would look good. The red collar would look attractive against the fair skin, too,
and I intended to keep the little one's polo neck as just a basic shape. The position of
the doll would break the large area of the tallest girl's skirt.

I sketched each child individually, then asked them to stand together, and I took a
few photographs. These were of some assistance but I didn't want to 'copy' them,

Anna Lucy Holly

Working drawings for circular portrait of Anna, Lucy and Holly

and in any case the shadows thrown were too harsh for me even to consider doing so. I had a good look at their hands. I had three pairs to draw and paint, so a good drawing was necesssary. The doll also had to be convincingly painted.

I felt this composition called for a circular frame, and had this made to a size of 10 cm diameter.

The three together

Watercolours: cobalt blue, cerulean blue, light red, Winsor red, viridian, cadmium orange, rose madder, Paynes grey, burnt umber, lemon yellow, vermilion
Brushes: size 000, 00, 1, 2, 3; ivorine 11 × 11 cm; water, rag; saucer; cosmetic sponge; designers gouache in white

METHOD

STAGE 1 I got my basic drawing to a satisfactory size, and the composition looked pleasing. I then outlined very firmly all the main angles: head, hands and arms.

STAGE 2 I placed this drawing beneath the ivorine and carefully traced through all the detail. It took time but was worth it. I knew I could only proceed confidently if this was correct. I also indicated some of the foliage in thin blue outline.

Stage 1

Stage 2

Stage 3

Stage 4

STAGE 3 I removed the drawing from beneath the ivorine so that I could keep checking up on it. I also made a tracing of the basic drawing to use to recheck the outline. This is a help once you are working in more detail and you can see more easily if any slight error is occurring in the proportions. I floated on thin washes in light red for all the girls' complexions, and used my tracing to indicate where I wanted form to be placed on the reverse side, turning over the ivorine and working on the back. I treated the blouse with a broad wash in cerulean blue, and also used this to indicate the doll's dress and the smallest child's tartan skirt. I turned back to the right side, and used pale burnt umber for the first application of colour for their hair. While this was still damp, I picked out some of the highlights.

I gradually built up the clothing in deeper shades of cobalt and Paynes grey, with a little stippling, some subtle hatching and finally, a shaped wash.

STAGE 4 I met the children again and was glad I had made notes about their clothing, as they were all dressed up now and looked quite different from the little outdoor children I had first met. Determined to stick to my original plan, I worked on the colouring, stippling a little vermilion into the cheeks. It looked very spotty, but as I had already laid in the light red first washes, I knew I could float over the spots with a damp brush and smooth them away.

All the features were very small, so I had to be very careful to keep the brushes clean, the water fresh and finally get it all under a magnifying glass for checking.

As usual, I tried not to concentrate too much on one area at a time, but moved about all over the miniature. This helped me to achieve harmonious colours, for I could use whatever I had on my brush, dropping it in somewhere else – in the clothing, foliage and so on. If one part is absolutely finished there is a danger that the rest could become boring and that must never happen!

The hands were outlined in light red. You might like to look back at p. 84 for ways of painting the hair. Hair always throws a soft blue shadow across the brow, but this edge doesn't want to look too sharp.

Finally, I put in a little sky background and included more detail in the foliage. It is always a good plan to look at a portrait by holding it up to a mirror; seeing it in reverse will show up any errors in composition and form.

DEMONSTRATION

STUDY OF LISA
(watercolour on ivorine)

Watercolours: French ultramarine, new gamboge, light red,
raw umber, Winsor red, cobalt blue, Paynes grey
Brushes: size 000, 00, 1, 2, 3; paper, pencil, eraser; water;
cosmetic sponge; ivorine 8.5 × 7 cm

METHOD

STAGE 1 After scaling down from an over-large photograph, and deciding the proportions were now correct, the pencil drawing was placed beneath the ivorine and traced through in cobalt blue. I decided to use a plain soft green background behind Lisa as it would show to advantage her hair colouring and clothing. So a thin mixture of French ultramarine and new gamboge were mixed and applied with a size 3 brush.

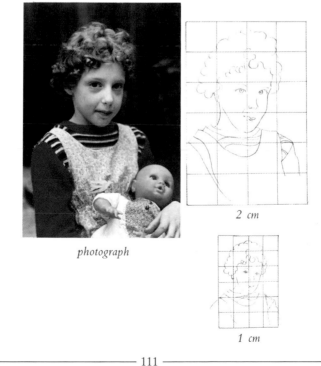

photograph

2 cm

1 cm

scaling down
for portraiture

The sweater was a rich red, and I used Winsor red for this, painting in just a few strokes to see the effect against the background. The hair was also to come next to the green background, and near to the red so I settled for a mixture of light red and raw umber for its lightest tones. I made several colour notes on the side of the work as I went along.

STAGE 2 Turning the ivorine over, I could just see my basic drawing and mixed a wash of Winsor red and cobalt blue to make a strong skin tone, painting this on the reverse side. When dry, I added in some simple shapes, the main areas of shadow on the forehead, down one side of the cheek, down and round the chin, and, less noticeably, on the opposite cheek. Again on the reverse side, I strengthened the drawing with a mixture of Paynes grey and cobalt and placed the colour in the long curve of the chinline. This does look strange, but the form is easily recognizable when seen through the ivorine on the correct side. In the next stage I intended to build up the form more emphatically.

Stage 1 Trace through outline drawing and correct it. Experiment with background and decide on the richest and deepest tones.

Stage 2 Turn to the reverse side and apply a deep wash for the darkest shadows.

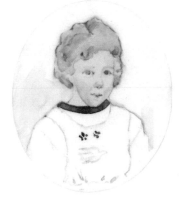

Stage 3 With the deep tones showing through the ivorine, start work on the top side.

STAGE 3 With the original photograph propped up in front of me, I was able to finalize the portrait. I liked the wavy lines the sweater made, the little mother of pearl brooch which I knew to be a present and, although the pinafore frock covered with a floral pattern does not tone in with the red of the sweater, it was typical of the child's clothing.

For the background, I used a small sponge which I dipped into a fairly dry mixture of French ultramarine and gamboge. If you decide to use this method of applying a background, practise it first, as the watercolour needs to be just the right consistency; not too wet, not too dry. The areas need to dry out before the next coat is firmly dabbed on. Considerable care is needed when coming up close to the features; if the background has been well established in the early stages the delicate areas of the cheek and neck can be re-established with a clean brush and water. This is much more difficult if a lot of work has been done; if so, an alteration to the background may be needed. I worked on the small touches which tell so much, such as wisps of hair and the little curves over the shoulder made by the sweater on top of the background colour. To finish I put in small strokes in the original thinner mixture of background colour, just to give it a little variety.

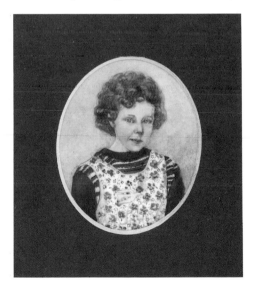

Stage 4 Finalise the portrait with a careful build-up of the form and careful attention to the background.

10 THE CHARM
OF THE SILHOUETTE

Shadowy shapes on a blank wall are mysterious and evocative – and silhouettes share something of these qualities, though the character of a person may be conveyed so vividly. The contemporary home can have an enchanting corner of hand-painted silhouettes.

The popularity of the silhouette began to grow in the late 17th century, when it became known as the 'poor man's miniature'; and silhouettes were often placed in a family album. At this time, the portrait miniature was much in vogue, painted in very fine detail, and silhouettes were obviously less expensive. 'Conversation pieces' depicting the family and their guests taking tea or conversing captured the style of dress and feel of the period.

Silhouettes were also cut out from black paper, with great skill and dexterity. The Frenchman, Edouart (1789–1861) travelled extensively in England, Ireland and America; he cut, free-hand, some 3,800 silhouettes. There may be people living today who will have sat for a few minutes on the pier at the seaside, or in a fair booth, and had a cut-out silhouette taken.

In mastering the art of silhouettes, the miniaturist can put aside colour and develop new skills, though there is scope for some use of colour in the embellishment of the form, as gold and graphite can be used to highlight the back of the head, clothing, or perhaps give a feeling of three-dimensional form. Red looks effective for a military gentleman, or for the robes of dignitaries. White, or delicate half-tones of grey can be used to indicate lace or a collar. The materials used are cheap and simple to acquire.

You'll need plenty of practice with silhouettes – for if you once get over-exasperated it could be a very trembly hand that tries to manipulate the brush!

Size of the miniature silhouette

Sizes of a silhouette can vary enormously, but to qualify as a miniature, the usual sizes mentioned on p. 7 apply. A cardboard aperture of 8 × 7 cm is a useful guide.

Materials

Graph paper; cheap white paper for initial sketches; good quality white paper (Designers' board, Hot Press) – it does not want to have a strong grain or be rough, or the surface will detract from the crisp outline you want to achieve; brushes: size 000, 2, 3; pencils, both hard and soft (6H to 3B) kept well sharpened; pencil sharpener, blade or knife; pen – Staedtler Marsmatic 700 or similar – don't use felt tips as these will give a fuzzy edge; designers gouache in black and white. Whether you choose to use other colours, such as red, blue or gold, is up to you; eraser; ruler; water; tracing paper; sticky tape; drawing board; frame to suit the subject, in either wood or gilt; a few oval mounts (mats) to help find the correct size; saucer to mix paint on.

Before you begin

Using scrap paper and a pencil, make a few circles and ovals the approximate size of the silhouette. Outline these with a pen. Some silhouettists outline with a fine brush, which is an excellent practice, and you could try both. You will soon discover which you prefer – or find you like to combine both pen and brush.

Faults the beginner may make

1 Features not prominent enough.

2 Chin too strong and cranium not wide enough.

The features occupy only one quarter of the whole area.

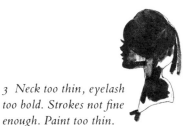

3 Neck too thin, eyelash too bold. Strokes not fine enough. Paint too thin.

4 Make a careful drawing, observing height of cranium above the eye and width at back of head.

Into these ovals you will apply black gouache paint, so let the edge dry and then mix a good quantity. No need to be frugal. The paint wants to be quite thick, but not dry. Take your size 3 brush and load it well, then begin to fill in the ovals, coming up closely against the outline. Next, try using the smaller brush and make little wobbly lines to indicate a few features. Fill these in with paint, again with the small brush; the smaller the area, the smaller the brush. This will give you practice in getting a crisp, clean edge. Let these examples dry and note how the paint shines on the surface. It needs to look wet all over by the time you have filled in the shape; if it looks scratchy or dry, you haven't loaded your brush sufficiently, so practise drawing and floating on the paint. Try not to smudge the outline, which can happen when everything else is correct.

Be prepared to paint several silhouettes before getting a good one that you like. They can be fairly quick to paint, once the drawing is correct, but there are a few hazards to avoid on the way; the main one is smudging the work, the other is not keeping it clean – rest your hand on an extra piece of paper while working. Have spare paper by you on which to make your strokes before actually getting started.

Some practice of this sort will help you before you follow through the demonstrations below.

DEMONSTRATION

SILHOUETTE OF REGENCY LADY AND GENTLEMAN

Materials: see list on p. 115. For the demonstration I used designers gouache in jet black, and an oval cut-out 7.5 × 6 cm.

METHOD

STAGE 1 Graph paper marked out to squares of 1 cm may help you, but try and draw freehand if you can. Trace the Regency lady and gentleman with the usual method, and transfer to your white paper. Outline with a fine pen or very fine brush. Keep very crisp and sharp, starting again if things go awry or the work gets smudged. Work on both heads at once – one can be drying while you outline the other.

STAGE 2 Next, mix your paint and then taking your smaller brush, well-loaded but not dripping, float the black paint into the features. Turn your work to the angle that best suits your hand. Fill in the rest of the head with your largest brush, which is

best done by going fairly fast, from one side to the other. The paint wants to look wet all over. Leave it to dry flat.

The gentleman can have narrow spaces left to indicate the lapels on his jacket, or these could look just as effective if the whole space is filled in. (Leaving a space is good practice in keeping a sharp edge.)

To help when cutting out the portraits, place convex glass over the paper, and outline with pencil, then cut with scissors. Always be careful to position the head well in its frame. Place your signature unobtrusively. (I usually put mine in the lower right-hand corner, though in a more elaborate silhouette it can be placed amongst a lace edge.)

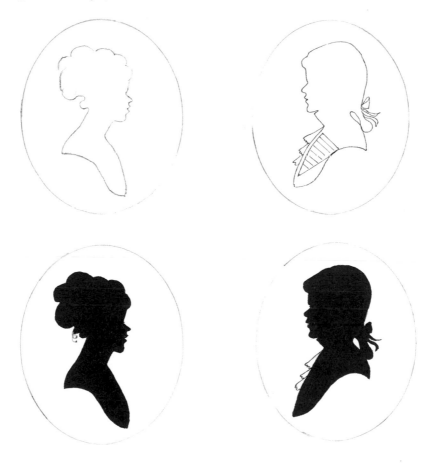

Stage 1
Keep a sharp outline. Fill in the features first.

Stage 2
Be careful not to smudge.

Shading *Pick out some shapes with thin paint.*

Embellishment *Use a sharp HB pencil to draw on top of the gouache.*

DEMONSTRATION

'THE ASCOT HAT'

Over the centuries, ladies have worn a hat to social functions, garden parties and race meetings being just two occasions when a lady might instruct her milliner to make her a truly individual hat. I had such an occasion when invited to a fancy dress party. Using an old sun hat as the base, I attached dried flowers in a spray to the crown, and made a bird out of velvet-covered cardboard. A chiffon scarf tied as a large bow completed the effect. I called it 'the Ascot hat', though I was unlikely ever to wear it to the famous races! It did, however, win first prize at the party. I thought my daughter looked charming wearing it, so decided to make it the subject of a silhouette.

Use the same materials and methods as for the previous demonstration, but leave some space round the neck so that you can paint in an effective high neckline. The bird, flowers and bow can be treated with thin watercolour, and then the final edges sharpened up.

Silhouette from a model

Working from life requires both sharp observation and good drawing skills. A good photograph is an excellent aid. Ask a member of your family to pose for you by standing against a white wall. The chin needs to be held as straight as possible – not too tilted or pulled into the neck, which gives an unbecoming line. A polaroid camera is good for a quick shot – you simply need a good outline. Take several and compare them. If you're lucky, the photograph may be to the scale you require, so you can just trace through the outline.

It is more demanding to work with a posed model, but a great deal more can be learnt by doing so – that inviting wisp of hair which may be lost in a photograph, for instance. Look for the length of neck, the sit of the clothes and the curve towards the front of the body. An impression of age, height and weight can be given very quickly in a silhouette. Finally, be sure to put the details of your name and that of your subject on the back of the picture.

Choose the frame with the subject in mind. Wooden frames with a thin inside edge of gilt look well, and are in keeping with tradition; they are called 'Acorn' frames and you can order them from frame makers. A plain mount, either rectangular or oval, placed over the painting with a narrow wooden frame also looks effective.

Embellishment

Embellishment is the word used for design and decorations applied on top of the black painting. The following can be used:

Gold, which comes in many shades, in both powder and paint form. One particular brand known as Superfine Metallic Bronze Powder, can be mixed with a little water and gum arabic and then applied to the black paint. A small brush is needed and the gold must be delicately applied or the work will look cheap and gaudy. Gold paint is readily available in small bottles and is applied with a small brush. Use on the back of the head, dress, jewellery and epaulettes.

Graphite, my own method is to embellish with a soft pencil, stroking in curls and other designs. It gives a soft silvery sheen on the plain black surface.

Colours, Gouache seems to me to be the best medium. Touches of red and blue will emphasize a feature of clothing.

'The Anniversary Silhouette'

'George Washington'
jet black gouache on paper
(after hollow-cut by N.P. Curtis,
in **Silhouette: a living art**
by Peggy Hickman)

'Lisa at Eighteen Months'

11
PAINTING WITH A PURPOSE

There are three ways in which you will probably approach the painting of miniatures: painting purely for pleasure, painting for a particular society's exhibition and painting to commission. Regardless of the end in mind, a love of the labour will always be essential.

You may prefer to paint entirely for yourself, to decorate your own walls and to give paintings to friends as presents. Once you have a bit of experience, however, you may want to paint for a specific exhibition. If so, it is wise to attend exhibitions and study the entries well. Take along your own work, and a magnifying glass, and when the gallery is quiet, place your work alongside something similar. Study the technique and see how problems have been solved. You will find ideas tumbling over themselves to get into your next miniature. You will also find work that makes you wonder how it ever came to be placed in the exhibition! But something can be learned from all entries. Remember that we are all individualists, and you will be developing a style of your own, so stick to it. Gather what appeals to you from other artists' work – somehow this will be stored magically in your mind and will emerge through your sable brushes and the manipulation of your fingers as your own interpretation.

Catalogues with lists of the artists participating are available at all exhibitions and if you are interested in taking part another time, enquire as to the conditions of exhibiting. If membership of a society is required before you can exhibit, ask what the terms of membership are. The usual procedure is to apply for an entry form and then submit work, for which a handing-in charge is made. The works then come before a selection committee, which is usually made up of the most prestigious members of the society, and then the best works are hung. Having some entries rejected does not always mean your work is not up to standard – it may mean that space is limited. Always take your rejects to the next exhibition and consult a member of the hanging committee about them. Hopefully, he will give a helpful explanation. Remember, too, that evaluation of paintings is a subjective matter, and rejection of your work by an art society or even a client, may not necessarily be a

criticism of the quality of your work. Try not to be discouraged, and whatever happens, keep persevering.

Membership of some societies has to be earned by having work accepted and hung over a period of years; others admit members after seeing a selection of work prior to an exhibition. You could join a local art society which shows all types of paintings and ask if you can make a display of your miniatures. This may often be very much more satisfactory than competing for space in an exhibition devoted entirely to miniatures. You may meet opposition from the hanging committee who will warn you about the vulnerability of miniatures, but persist. Have a display case made with protective glass and a lock, and place your work inside on an attractive background. The case may barely take up the same space as a conventionally-sized painting. A good wooden frame can be used to make a display case, and it will also be attractive in showing your work in your own home.

You will be asked to put a price on your exhibits and give a title to each entry. Read the society's rules carefully, to avoid any misunderstanding should a client request a commission. Most galleries and societies will take a percentage of any sales or commissions arising from an exhibition.

Working to commission really means painting for money, and this can be very inhibiting. Don't undertake commissions until you are confident of your work. Even so, every commission is, I'm afraid, tinged with anxiety, so don't rush the transaction. If a request has come through a gallery, arrangements for your fee will be made for you, and sittings can be planned to suit you. Photographs of the subject may be sent to you before you meet a client. You will need to bear in mind how much time will be involved, and consider how appealing you find the subject. Always accept a challenge if you can – stretching yourself may well mean you reach new heights, and you will certainly discover aspects of miniature painting you have not previously had to cope with. It is an excellent opportunity to develop as an artist. In some cases, a deposit is requested by the gallery through which the transaction was made, and this may be retained for the artist if the client doesn't find the finished work satisfactory. There are many different regulations and each art society and gallery is different.

When accepting a commission from a personal contact, it is just as well to be as business-like as possible. It is far easier to deal with strangers than to negotiate a fee with friends. You'll probably find that when you first meet to talk about the painting, all aspects of the miniature will be discussed, and finally the client will ask

if some idea of the cost can be given. This opening will come as a relief, and you can then talk freely about your charges. It is quite difficult to price your own time and skills and guidelines are hard to offer, but if you study work on sale in an exhibition, you will know roughly what the market will stand. You can discuss the cost of framing and materials easily enough, so mention these first. When fixing a price, you should consider extra details such as hands in a portrait, details of decorations or medals to be included, jewellery and so on, if these will mean your spending extra time on the work. If you are arranging matters yourself, fees are always negotiable, and if you are painting several miniatures for a client an overall sum can be arranged. But finding a fee that will suit the purse of all clients is tricky. The main thing is not to underprice your work – after all, you are giving a very personal service.

It is as well always to write a letter with all the details of a commission stated in it: type of frame, size, fee, and possible delivery date. This will keep you in order and be appreciated by the client.

Although outside the scope of this book, miniature painting is an attractive additional skill for the calligrapher. Silhouettes, too, are very effective when combined with lettering for greetings cards and invitations. You might also consider painting for the doll's house; such paintings must be to scale, and appropriately framed – tiny portraits for the drawing room, a still life for the dining room and so on. Acrylics are a good medium to use for these, as such paintings need to be brightly coloured.

Miniature painting can be as varied and individual as larger works – it is up to you to work at technique and further your own ideas. We owe an enormous amount to the traditions and techniques developed in the past, but today we have new mediums and surfaces to explore. We must, therefore, paint our miniatures with a touch of originality and lay down new traditions for the future.

Happy painting!

List of Suppliers

All well-stocked art shops should be able to provide the papers, paints, pens, crayons and other drawing materials necessary.

UNITED KINGDOM

Materials
For ivorine, vellum, frames, and general artist's materials:
L. Cornelissen & Son, 105 Great Russell Street, London WC1B 3RY 01–636–1046

Frames
All local frame makers should be able to provide you with mounts and wooden frames of whatever size you need.

Videotapes
Suppliers of instructional videos on painting miniatures are:
Seeba Film Productions, 9 St Johns Street, Lechlade, Glos. GL7 3AT 0367–52389

Mail Order Specialists
For ivory, ivorine, vellum, brushes and frames (though not square or rectangular frames in wood) specifically for the miniaturist:
R.J.W. Products, 1 Georgian Close, Hayes, Bromley, Kent BR2 7RA

For frames of all sizes for the miniaturist including some wooden oval frames:
Framecraft Miniatures Ltd., 148–150 High Street, Aston, Birmingham B6 4US

UNITED STATES

A good general supplier of art materials is:
Winsor & Newton, 555 Winsor Drive, Secaucus, New Jersey

For ivorine and specialist brushes, and details of societies that exhibit miniatures contact:
Miniature Painting Etc., P.O. Box 7659, Clearwater, Florida 34618/7659

Galleries and Societies

UNITED KINGDOM

The Hilliard Society, Wells, Somerset.

N.A.P.A. (National Acrylic Painters Association), 134 Rake Lane, Wallasey, Wirral L45 1JW has an acrylic miniatures section.

The Royal Society of Miniature Painters, Sculptors and Gravers, 17 Carlton House Terrace, London S.W.1.

The Society of Limners, 2 Glentrammon Close, Green Street Green, Orpington, Kent BR6 6DL.

Society of Miniaturists, 41 Lister Street, Riverside Gardens, Ilkley, West Yorkshire LS29 9ET.

Society of Botanical Artists (*March*), Society of Women Artists (*May/June*) and the Royal Society of Miniature Painters, Sculptors and Gravers (*October/November*) all hold annual exhibitions at the Westminster Central Hall, Storey's Gate, London S.W.1.

UNITED STATES

Arizona Husberg Fine Art Gallery, 7133 E. Stetson Drive, Suite 1, Scottsdale, AZ 85251 Tel. 602/947–7589.

Joy Tash Gallery, 7236 E. First Ave., Scottsdale, AZ 85251 Tel. 602/945–0195.

Settlers West Gallery, 6420 N. Campbell Ave., Tucson, AZ 85718 Tel. 602/299–2607.

California GWS Galleries, 256390 Carmel Rancho Lane, Carmel, CA 93923 Tel. 800/843–6467 or 800/255–6677.

Colorado Aspen Art Museum, 590 N. Mill St., Aspen, CO 81611, Tel. 303/925–8050.

El Dorado Fine Arts Gallery, 2504 W. Colorado Ave., Colorado Springs, CO 80904 Tel. 303/634–4075

Connecticut Greenwich Workshop Galleries (GWS), 2600 Post Road, Southport, CT 06490, Tel. 800/243–43260.

Florida Miniature Art Society of Florida. President (1987), Mrs. Sarah Heyward, 1871 N. Washington Ave., Clearwater, FL. 34615.

Georgia Georgia Miniature Art Society. President (1987) is Mrs. Irene Kemp, 475 Mayes Road, Powder Springs, GA. 30073, Tel. 404/422–2930.

Minnesota Miniature show usually held in September. Write Mr. W. Grewe, Route 1, Box 24, Gibbon, MN 55335 Tel. 507/834–6335.

Wild Wings Gallery, S. Highway 61, Lake City, MN 55041 Tel. 612/345–5355

Montana Montana Miniature Art Society, Pegee Haman, 3030 Stinson, Billings, MT 59102, Tel. 406/656–1167.

Artists' Union Gallery, 31 S. Willson Ave., Bozeman, MT 59715, Tel. 406/586–3636.

La Petite Gallerie, 23 West Main, Bozeman, MT 59715.

New Jersey Miniature Art Society of New Jersey, 1591 Broad St., Bloomfield, NJ 07003, Tel. 201/338–0026.

New Mexico Gallery La Luz, Box 159, La Luz, NM 88337, Tel. 505/437–9524.

Oklahoma Gilcrease Institute, 1400 Gilcrease Museum Rd., Tulsa, OK 74127, Tel. 918/583–3122.

Texas Altermann Art Gallery, 2504 Cedar Springs Rd., Dallas, TX 75201, Tel. 214/871–3035.

Collectors Covey, 15 Highland Park Village, Dallas, TX 75205, Tel. 214/521–7880.

Musselman River Walk Gallery, 123 Losoya Ave., B–19 San Antonio, TX 78205, Tel. 512/226–2255.

Washington D.C. Washington Society of Miniature Painters, Sculptors and Gravers. President, (1987) Mrs. Margaret Hicks, 1607 Crittenden St. NW, Washington, DC 20011 Tel. 202/291–6404.

Wyoming Laramie Art Guild, PO Box 583, Laramie, WY 82070. Tel. 307/745–5047.

Trailside Galleries, P.O. Drawer 1149, Jackson, WY 83001. Tel 307/733–3186.

CANADA

Toronto Del Bello Gallery, 363 Queen Street West, Toronto, Ontario M5V 2A4, Tel. 416/593–0884.

Index